Vincent van Gogh

Vincent van Gogh

ARTIST OF HIS TIME

Griselda Pollock and Fred Orton

E. P. Dutton · New York

For Emile Meijer

Phaidon Press Limited, Littlegate House,
St Ebbe's Street, Oxford

First published 1978
Published in the United States of America by
E. P. Dutton, New York
© 1978 by Phaidon Press Limited
All rights reserved

ISBN 0 7148 1883 6 (cased)
ISBN 0 7148 1906 9 (paperback)
Library of Congress Catalog Card Number: 78–56652

Printed in Great Britain by
Waterlow (Dunstable) Limited

List of Plates

Select Bibliography

J. B. de la Faille, *The Works of Vincent van Gogh*, Amsterdam and London 1970

L. Gans, F. Gribling, A. Hammacher, E. Joosten, R. Oxenaar *et al.*, *Vincent van Gogh Catalogue*, Otterlo 1970

Vincent van Gogh, *Verzamelde Brieven*, Amsterdam 1974

Vincent van Gogh, *Complete Letters*, London and New York 1959

J. Brouwer, J. Vis, J. Siesling, *Anthon van Rappard*, Amsterdam 1974

W. van Gulick, F. Orton, *Complete Catalogue of van Gogh's Collection of Japanese Prints*, Amsterdam 1978

A. M. Hammacher, *Genius and Disaster—Ten Creative Years*, New York 1969

S. Loevgren, *The Genesis of Modernism*, Bloomington 1971

H. Marius, *Dutch Painting in the Nineteenth Century* (1908), new ed. 1973

F. Novotny, 'Reflections on a Drawing by van Gogh (The Factory)', *Art Bulletin*, March 1953

F. Orton, *Van Gogh's Japonisme*, M.A. Thesis, London University 1969

F. Orton, 'Van Gogh's interest in Japanese Prints' *Vincent* I: 3, 1971

D. Outhwaite, *Van Gogh's Auvers Period*, M.A. Thesis, London University 1969

R. Pickvance, *English Influences on van Gogh*, London 1974

G. Pollock, *Van Gogh and the Hague School*, M.A. Thesis, London University 1972

G. Pollock, 'Van Gogh, Rembrandt and the British Museum', *Burlington Magazine*, November 1974

J. Rewald, *Post-impressionism*, New York 1962

M. Roskill, *Van Gogh, Gauguin and the Impressionist Circle*, London 1970

M. Schapiro, *Van Gogh*, New York 1950

B. Welsh-Ovcharov, *Van Gogh in Perspective*, New Jersey 1974

Five and thirty years ago the glory had not yet departed from the old coach roads. . . . The passenger on the box could see that this was the district of protuberant optimists, sure that old England was the best of all possible countries . . .: the district of clean little market-towns without manufactures, of fat livings, an aristocratic clergy, and low poor-rates. But as the day wore on the scene would change: the land would begin to be blackened with coal-pits, the rattle of handlooms to be heard in hamlets and villages. Here were powerful men walking queerly with knees bent outward from squatting in the mine, going home to throw themselves down in their blackened flannel and sleep through the daylight . . .; here were the pale, eager faces of handloom-weavers, men and women, haggard from sitting up late at night to finish the week's work, hardly begun till the Wednesday. Everywhere the cottages and the small children were dirty, for the languid mothers gave their strength to the loom. . . . The gables of the Dissenting chapels now made a visible sign of religion, and of a meeting-place to counterbalance the ale-house, even in the hamlets. . . . The breath of the manufacturing town, which made a cloudy day and a red gloom by night on the horizon, diffused itself over all the surrounding country, filling the air with eager unrest. Here was a population not convinced that old England was as good as possible.

GEORGE ELIOT, *Felix Holt* (1866), PART I, CH. I
(Read by van Gogh, 1878)

The drama of his life did not embellish but obscure the value of his work.

MAX LIEBERMANN

There is certainly an affinity between a person and his work, but it is not easy to define what this affinity is, and on that question many judge quite wrongly.

VINCENT VAN GOGH

Born on 30 March 1853, Vincent van Gogh died on 29 July 1890 from self-inflicted wounds. He was subject to a neurophysiological disorder, known as psychomotor epilepsy, which only began in the late 1880s. During the brief periods of sporadic attacks he experienced changes of perceptions, moods and states of mind. This condition did not affect what or how he painted.

Van Gogh left home at the age of sixteen to be apprenticed to an art dealing firm, Goupil & Company, in the Hague. In 1880 he decided to become an artist after a decade of experiment with a variety of careers; art dealing (1869-76), teaching (1876), bookselling (1877), studying theology and evangelizing (1877-9).

When van Gogh left his home in rural Brabant in 1869 the full effect of the Industrial Revolution had yet to be felt in Holland. However, the change of sensibility which this economic and social upheaval had demanded of writers and artists in the more advanced industrialized countries, England and France, was already familiar to van Gogh by 1880 through his intense reading of nineteenth-century novelists, George Eliot, Charles Dickens and Emile Zola. His reading was complemented by an equally passionate admiration for the painters of seventeenth-century Holland, and the modern French and Dutch schools of peasant painters and landscape painters whose work was infused with a romantic nostalgia for a timeless, rural past. He was probably also acquainted with Dutch criticisms of the commercial and colonial aspects of modern society in the influential anarchist novel *Max Havelaar* (1865) by Multatuli.

In the spring or early summer of 1880, van Gogh wrote to thank his brother, Theo, for a gift of fifty francs, the first of what were to become regular financial payments which enabled him to commence and pursue his work as an artist. This letter (133), which broke a long silence and period of estrangement between the brothers, gives a lengthy exposition of van Gogh's situation at this turning-point. A careful analysis of the text provides the keys to Vincent's future concerns and practice as an artist. It reveals his uncompromising determination and his conscious and deliberate manipulation of his younger brother for the fulfilment of his ambitions.

Van Gogh's letters require careful and critical reading. Useful as they may be as documentation, they should not be regarded as merely spontaneous outpourings or unselfconscious reflections. They are carefully considered. They constitute a discourse on modern art and the role of the artist in modern society. Van Gogh saw his correspondence as a necessary adjunct, as a complementary *œuvre* to his paintings and drawings. The letters are his deliberate contribution to

7

modern literature. Through them he prepared and tailored a picture of himself and a view of his art which has survived, more or less intact, through the complicity of his brother Theo, whose role in this characteristically modernist strategy of self-justification and documentation should not be underestimated.

Letter 133, one of the most important to survive, exemplifies the character of van Gogh and the structures of his thought and presentation. It is moreover the letter which announces his decision to become an artist, though, characteristically, this is never stated directly. We have to map out the structures of thought in this text in order to discover their true meanings.

The letter begins,

I am writing you with some reluctance, not having done so in such a long time, for many reasons. To a certain degree you have become a stranger to me, and I have become the same to you, more than you think; perhaps it would be better for us not to continue in this way. Probably I would not have written you even now if I were not under the obligation and necessity of doing so, if you yourself had not given me cause.

It concludes,

For the present I shake hands with you, thanking you again for the help you have given me. If you wish to write me one of these days, my address is c/o Ch. Decrucq, Rue de Pavillon 3, Cuesmes, near Mons.

And you know a letter from you will do me good.

Reluctantly van Gogh apologized for a long silence, which might have continued but for the obligation to thank Theo for his gift of fifty francs. His unstated purpose in the letter was, however, the need to win his brother's indulgence and to ensure the continuation of both his financial and moral support. In order to re-establish their relationship, it was necessary to explain his self-imposed isolation. The main text of the letter therefore treats key themes of alienation and *rapport*, moral approval and financial need. It begins and

ends in the same vein, establishing the basis of reconciliation. Van Gogh's tone is by turns ingratiating and threatening, aggressive and persuasive, apologetic and demanding. Hence, at the end, in thanking Theo for the help he has given, Vincent is also anticipating its regular continuation.

By way of persuasion, van Gogh gives an account of his present state, isolated not only from his brother, but estranged from his family and alienated from his bourgeois background. After his appointment as an evangelist to the miners of the Borinage had been terminated by the Belgian Committee for Evangelization, van Gogh had wandered through the Borinage district homeless, unemployed and in search of a new direction. He represents this period with a metaphor,

As moulting time—when they change their feathers—is for birds, so adversity or misfortune is the difficult time for us human beings. One can stay in it—in that time of moulting—one can also emerge renewed . . .

Van Gogh thus reassures Theo that no drastic change or deterioration has occurred, but rather, he is engaged in a natural, cyclical process from which he will emerge renewed, superficially different perhaps, but essentially unchanged. The metaphor of moulting birds also carries a philosophical meaning derived from van Gogh's acquaintance, through reading Taine's *History of English Literature* (1863), with the ideas of the influential Victorian philosopher, Thomas Carlyle. Carlyle inveighed against the moral deadness of his age, its hypocritical judgements of people and moral questions, its complacent acceptance of prosperity for the very few and commercial success as man's supreme goal. In *Sartor Resartus* (1837), Carlyle's critique is framed in terms of an extended metaphor, the philosophy of clothes. Social conventions and customs are seen as the mere coverings, which conceal, if not obscure, the inner spiritual truths. Van Gogh adopts this metaphor in

accounting for his loss of an established position in society,

One of the reasons why I am unemployed now, why I have been unemployed for years, is simply that I have different ideas from the gentlemen who give the places to men who think as they do. It is not merely a question of dress, which they have hypocritically reproached me with; it is a much more serious question, I assure you.

Van Gogh directs a vehement attack on those blinkered churchmen and tyrannical art-world academicians who maintain outward conventions and established institutions against all new ideas and fresh aspirations. In doing so, he asserts his allegiance to alternative, independent and radical groups. And the sentence, 'I must tell you that with evangelists it is the same as with artists,' intimates a new direction in his thinking.

However, to those with a vested interest in maintaining the present social system and its institutions, van Gogh's ideas and behaviour appear eccentric, foolish, alarming. In a superbly poetic passage he conveys to his brother the great gulf of misunderstanding that exists between how the world regards him and how he truly is, thus subtly displacing responsibility for his situation on to others,

A caged bird in the spring knows quite well that he might serve some end; he is well aware that there is something for him to do, but he cannot do it. What is it? He does not quite remember. Then some vague ideas occur to him, and he says to himself, 'The others build their nests and lay their eggs and bring up their little ones;' and he knocks his head against the bars of the cage. But the cage remains, and the bird is maddened by anguish.

'Look at that lazy animal,' says another bird in passing, 'he seems to be living at ease.'

Yes, the prisoner lives, he does not die; there are no outward signs of what passes within him—his health is good, he is more or less gay when the sun shines. But then the season of migration comes, and attacks of melancholia—'But he has everything he wants,' say the children that tend him in his cage. He looks through the bars at the overcast sky where a thunderstorm is gathering, and inwardly he rebels against his fate. 'I am caged, I am caged, and you tell me I do not want anything, fools! You think I have everything I need! Oh! I beseech you liberty, that I may be a bird like other birds!'

Later, van Gogh defines the cage as the prison of prejudice, misunderstanding, fatal ignorance, distrust, false shame, and poverty. Liberation will come with the re-establishment of trust, sympathy and brotherly love. Both Theo's money and his renewed belief in van Gogh are therefore posed as the solution to his present predicament.

Van Gogh presents himself as someone who is misunderstood and unrecognized. Despite a change in his external appearance and life-style, his inner self has remained constant. That self is, admittedly, unconventional, foolish, outspoken, but above all van Gogh sees himself as a man dominated by intense drives and enthusiasms,

I am a man of passions, capable of and subject to doing more or less foolish things, which I happen to repent more or less, afterwards. Now and then I speak and act too hastily, when it would have been better to wait patiently. I think other people sometimes make mistakes. Well, this being the case, what's to be done? Must I consider myself a dangerous man, incapable of anything? I don't think so. But the problem is to try every means to put those selfsame passions to good use. For instance, to name one of my passions, I have a more or less irresistible passion for books, and I continually want to instruct myself, to study if you like, just as much as I want to eat my bread. *You* certainly will be able to understand this. When I was in other surroundings, in the surroundings of pictures and works of art, you know how I had a violent passion for them, reaching the highest pitch of enthusiasm. And I am not sorry about it, for even now, *far from that land, I am often homesick for the land of pictures.*

In this way, van Gogh juxtaposes his real isolation from his family and society with his desire to discover another kind of environment, a home, to which he can properly belong, a true centre of affection, where he can find rest, refuge and satisfaction. He

identifies this spiritual home with the 'land of pictures', the medium through which he can find his place again in society. To this end, the 'thorough study of pictures and the love of books is as sacred as the love of Rembrandt'; the one complements the other. Moreover, he believes that literary style and language can be compared to an artist's brushwork 'quivering with fever and emotion'. Thus, 'one must learn to read just as one must learn to see and learn to live.' The interrelation of word and image revealed subsequently in van Gogh's own practice is announced in this letter, and the future directions and preoccupations of his work are suggested by the affinities he finds between the artists and writers whom he names in this decisive letter,

. . . there are many things which one must believe and love. There is something of *Rembrandt* in Shakespeare, and of *Correggio* in *Michelet*, and of *Delacroix* in Victor Hugo; and then there is something of Rembrandt in the Gospel, or something of the Gospel in Rembrandt—whichever, it comes to the same thing if only one understands it properly, without misinterpreting it and considering the equivalence of the comparisons, which do not pretend to lessen the merits of the original personalities. And in Bunyan there is something of *Maris* or of *Millet*, and in Beecher Stowe there is something of Ary Scheffer. (*Our italics*)

Within a few months of writing thus to Theo, van Gogh was busy drawing, teaching himself with contemporary copy books and reproductions. From the beginning his works reveal remarkable facility and a sure grasp of pictorial composition. One of the early pictures, *Miners Going to Work* (fig. 1), borrows a motif and style from the French painter, Jean François Millet (1814-75), and his *Going to Work*, 1850-1 (Glasgow City Art Gallery). These are combined with his own observations of the miners, to whom he had so zealously ministered in 1878-9, and his response to the peculiar landscape of the Borinage with its shrivelled blackthorn hedges, stark against white snow, the bowed and bent figures of the Borin miners dwarfed by the mine workings and the man-made mountains of coal and slag. Van Gogh brings all these elements together, representing with black lines on white paper what George Eliot had described in her verbal picture of the contrast of the old rural and modern industrial worlds in *Felix Holt* (see p. 6). To this van Gogh adds his own symbolism. Not only had he earlier compared the blackthorn bushes against a snowy ground to 'black characters on white paper—like the pages of the Gospel' (Letter 127), but he had seen the miners, the men who walk in darkness, as symbolic of the whole message of the Gospel, whose foundation is 'the light that rises in darkness' (Letter 126).

A drawing completed seven months later in April 1881 (fig. 2), after van Gogh had moved to Brussels in search of more intense instruction, bears witness to both the increasing technical accomplishment and the density of meaning he intended his pictures to convey through the deliberate positioning of highly significant elements.

The drawing, to which van Gogh gave an English title, 'The Bearers of the Burden', shows several women miners returning home carrying sacks of coal they have gathered from the slag heaps to burn in their own homes. They are not bent double under the weight of the coal, but under a metaphysical burden. They stagger in slow procession across a sombre landscape, which itself is burdened with the outward, visible signs of the powerful institutions which spiritually and materially determine the miners' existence. The figures, whose dark tones are scarcely distinguishable from those of the blackened landscape, merge into the ground. In the lighter background two churches break the skyline, one Catholic and one Protestant, each segregated from the other by the vertical supports of the mine's viaduct, and dominating the huddle of the miners'

10

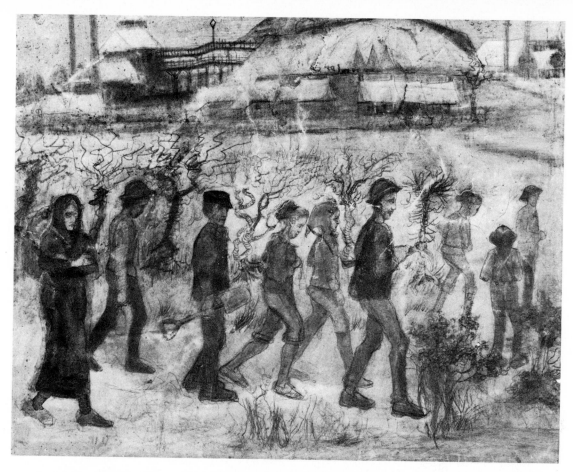

1. *Miners Going to Work*. September 1880. Pencil on paper, 44.5 × 56 cm. (17½ × 22 in.)
Otterlo, Rijksmuseum Kröller-Müller

2. *Miners' Women Carrying Sacks* ('*The Bearers of the Burden*'). April 1881.
Pencil, brush and pen on paper, 43 × 60 cm. (17 × 23½ in.) Otterlo, Rijksmuseum Kröller-Müller

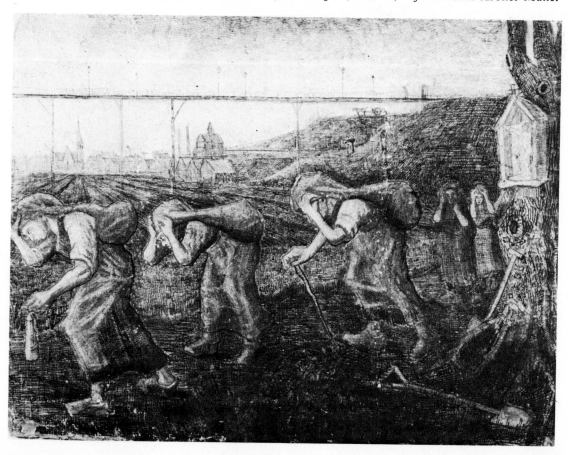

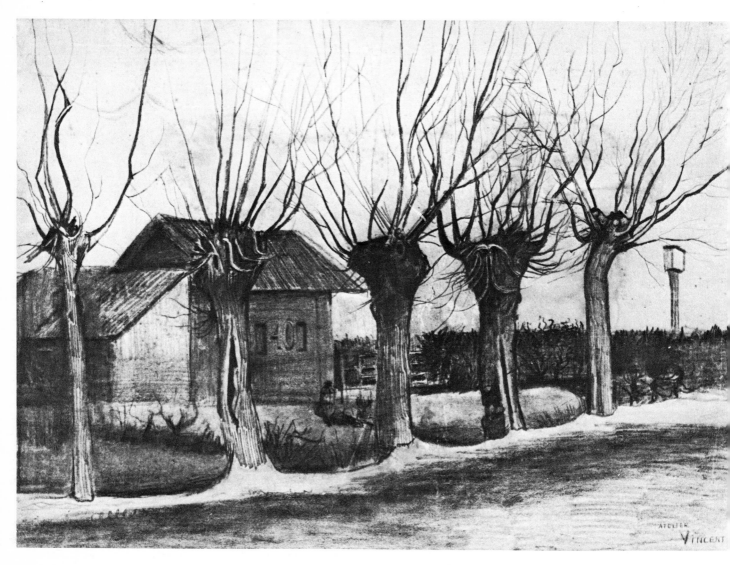

3. *The House of the Railway Attendant.* October 1881. Charcoal on paper, 44 × 59 cm. (17⅜ × 23¼ in.)
Otterlo, Rijksmuseum Kröller-Müller

dwellings. Although the church towers aspire hopefully upward, they are enclosed within the structure of the viaduct, a sign of the otherwise absent mine and its underground world, which also appears to dominate the bent figures in the foreground. Three women lead the procession across the picture, past a gnarled tree trunk, on which hangs a Calvary showing Christ on the Cross. In this way the material, temporal world is juxtaposed to the spiritual. The last agony of Christ is the symbolic equivalent of the miners' own passion; its presence changes how we see the daily return from work. Van Gogh shows the miners indifferent to Christ's agony, passing unheeded that which is offered them by institutionalized religion.

After a brief stay in the city of Brussels, to which he had gone from the Borinage, van Gogh returned to Brabant, and, in his drawings, he concentrated on studies of agricultural workers, the most important of which was *The Sower* (fig. 4). Van Gogh's enthusiasm for this figure derived in part from

12

his admiration for Millet's famous image, a reproduction of which he had copied repeatedly in 1880-1, and in part from the biblical connotations of the Parable of the Sower. It came to represent for van Gogh a pictorial symbol of his artistic and political credo, the need to live in harmony with nature's cycles, be rooted in the earth, in the real, to work from nature and celebrate its wholesomeness and fertility. Moreover, the Sower satisfied his need to create an entirely modern imagery, secular and free from all conventions, which was none the less imbued with a displaced, sublime, almost religious emotion.

This early study of a sower is an example of van Gogh's desire to find a style and technique appropriate to his commitment to modern realism. The angularity, the awkward stiffness and rough texture, the old work-worn face refuse all prettification or picturesqueness and, however sublime the idea that lies behind the subject, the drawing bespeaks real work.

Throughout van Gogh's *œuvre*, a fascination with the working human figure vies with his feeling for landscape, the earth on and in which the peasant labours. The two were closely linked in his mind, and he often drew or spoke about one in terms of the other (see fig 3):

Today I have been working on old drawings from Etten, because in the fields I saw the pollard willows in the same leafless condition. . . . Sometimes I have such a longing to do landscape . . .; and in all nature, for instance in trees, I see expression and soul, so to speak. A row of pollard willows sometimes resembles a procession of almshouse men. Young corn has something inexpressibly pure and tender about it. . . . The trodden grass at the roadside looks tired and dusty like the people of the slums. A few days when it had been snowing, I saw a group of Savoy cabbages standing frozen and benumbed, and it reminded me of a group of women in their thin petticoats and old shawls which I had seen standing in a little hot-water-and-coal shop early in the morning.

(Letter 242, November 1882)

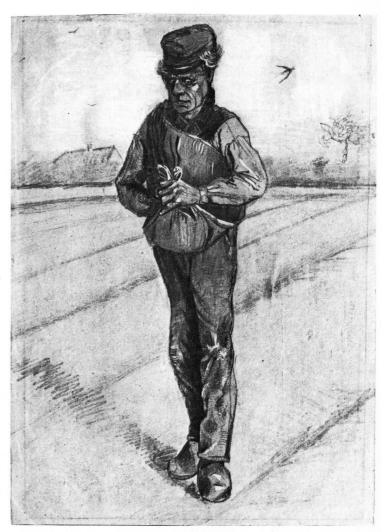

4. *The Sower*. September 1881. Chalk, pencil and wash on paper, 61 × 45 cm. (24 × 17¾ in.) Otterlo, Rijksmuseum Kröller-Müller

In December 1881 van Gogh settled in the city of The Hague, the main centre of modern Dutch art. He was acquainted with the leading artists and the work of the Hague School, Anton Mauve (1838-88), Jacob Maris (1837-99) and Josef Israëls (1824-1911), from his work in the 1870s at Goupil & Co., the school's major dealers. This move from country to city, from solitary work to a more gregarious life in an avant-garde artistic milieu, begins a pattern that is repeated throughout his life, from The Hague to Drenthe and Nuenen, then to Antwerp and Paris, from which he went to the Provençal countryside and finally the rural village of Auvers. In The Hague he anticipated the companionship of like-minded artists, but his uncompromising personality and eccentric, anti-bourgeois behaviour soon cut him off from the respectable members of this group. He fraternized, however, with younger artists, de Bock, van der Weele and Breitner (1857-1923), with whom he set out on sketching trips, scouring the poorer quarters of the city for motifs like soup kitchens, third class waiting rooms, prostitutes and the aged poor, inmates of the almshouses known in Dutch as 'orphanmen' (fig. 5). Breitner and van Gogh shared an interest in modern French realist novels, especially Zola and the de Goncourt brothers. The latter had encouraged artists to depict the lives of ordinary people and the poorer inhabitants of the new growing cities.

Shortly after arriving in the Hague, van Gogh started to collect engravings from English and French illustrated magazines, some of which he knew from his time in England in the 1870s. He was particularly interested in the work of Frank Holl, Hubert Herkomer and Luke Fildes, whose drawings he admired because they aroused sympathy for the poor, old and outcast. It became his ambition to work as an illustrator producing drawings not only of the people, but for the

5. 'Orphanman' with Walking Stick. September-December 1882. Pencil on paper, 50 × 30.5 cm. (19¾ × 12 in.) Amsterdam, National Museum Vincent van Gogh

people. To this end he explored graphic techniques, notably new forms of lithography (figs. 11 and 12). His desire to produce a popular art resolved itself into a scheme for a series of drawings and lithographs of types of the people, aimed at a very different public from that of the English magazines,

No result of my work could please me better than that the ordinary working people would hang such prints in their room or workshop.

(Letter 245)

14

The most complex and intriguing work of The Hague period is *Sorrow* (fig 6), worked up from a drawing for the series of lithographs. It is one of the most remarkable images of a nude woman in European art, although there are precedents in Northern art for the use of the naked female body to express pathos rather than available sexuality in, for instance, Rembrandt's *Bathsheba* (Paris, Louvre). However the woman in *Sorrow* is pregnant and the pathos derives from her posture of despair and the suggestion that she has been abandoned in her condition, provided by the inscriptions on the drawing—not only an English title, but a quotation from the French philosopher, Jules Michelet, 'How can it be that there is on earth a woman alone and abandoned?'

The model was a pregnant prostitute whom van Gogh had found on the streets and taken into his home under the influence of Michelet's empassioned appeal in his books on Love and Woman for the rescue of modern woman from the dangers that nineteenth-century society placed her in.

Van Gogh has, however, radically changed a simple, though unusual, nude study into a many-layered comment on the issues of prostitution and love, themes which had engaged so many nineteenth-century thinkers, novelists and artists. The treatment is emphatic, linear, harsh; the figure is situated outside, at a roadside, next to thorn bushes. Yet the despair and pathos of the image of woman vies with another quite optimistic meaning, once the elements of this drawing, fertility, blossoms, nature are placed in the context of van Gogh's personal symbolism. From study of his letters we can perceive that he is making an analogy between a pregnant prostitute and the other outsider and outcast, the artist, as well as a commentary on the nature of creative work.

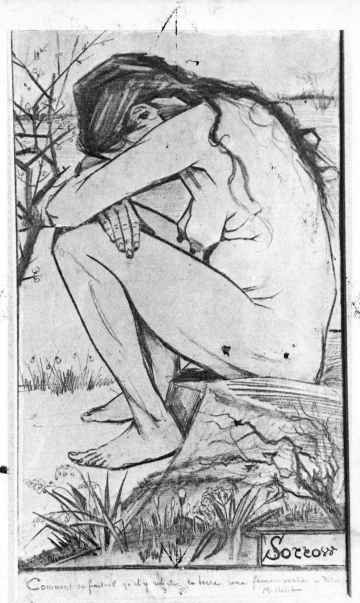

6. *Sorrow*. April 1882. Pencil, pen and ink, 44.5 × 27 cm. (17½ × 10⅝ in.) Walsall, Museum and Art Gallery, The Garman Ryan Collection

So you see that I am in a rage of work, though for the moment it does not produce very brilliant results. But I hope these thorns will bear their white blossoms in due time, and that this apparently sterile struggle is no other than the labour of childbirth. First the pain and then the joy.

(Letter 136, 1880)

The whore in question has more of my sympathy than my compassion. Being a creature exiled, outcast from society, like you and me who are artists, she is certainly our friend and sister.

(Letter to Bernard 14, 1888)

15

The other, 'The Roots' [fig. 7] *shows some tree roots on sandy ground. Now I tried to put the same sentiment into the landscape as into the figure: the convulsive, passionate clinging to the earth, and yet being half torn up by the storm. I wanted to express something of that struggle for life in that pale slender woman's figure as well as in the black, gnarled and knotty roots.*

(Letter 195, 1882)

For myself I learn much from Father Michelet. Be sure you read L'Amour et La Femme. . . . *The men and women who stand at the head of modern civilization —for instance Michelet and Beecher Stowe, Carlyle and George Eliot and so many others—they call to you. . . .*
'Oh, man, wherever you are, with a heart in your bosom, help us to found something real, eternal true. . . . Let your profession be a modern one and create in your wife a free modern soul, deliver her from the terrible prejudices that enchain her.'

(Letter 160, 1881)

7. *Study of a Tree—'Roots'*. April 1882. Black and white chalk, black ink, pencil and watercolour, 51 × 71 cm. (20 × 28 in.) Otterlo, Rijksmuseum Kröller-Müller

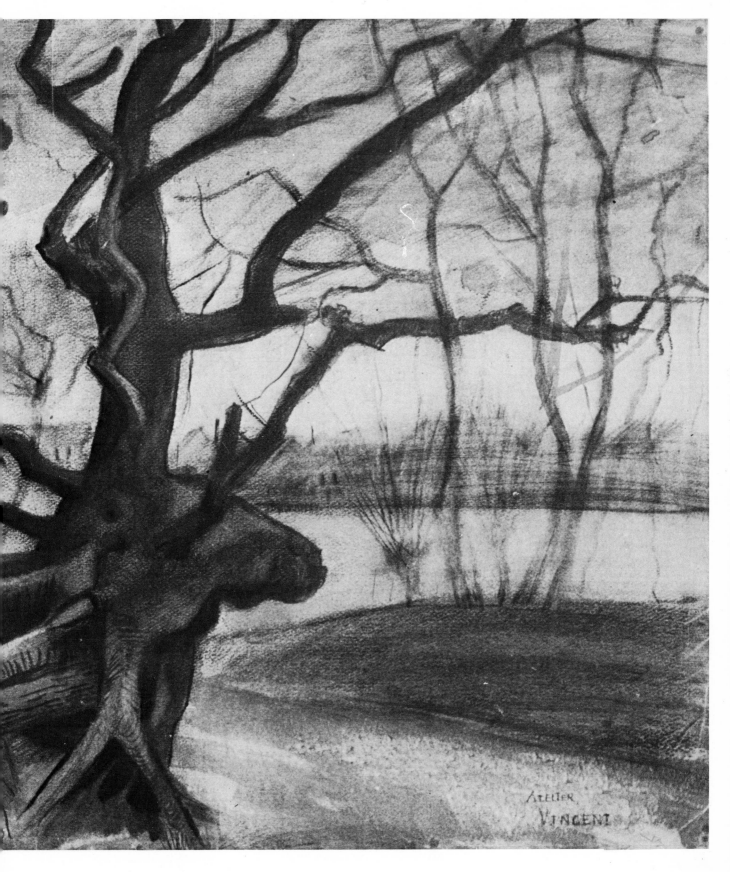

The image of the reader was for van Gogh a quintessentially modern subject. In his art he aspired to equal the achievements of contemporary literature. His letters are full of admiring references to portrayals of readers by artists as diverse as Meissonier (1815-90), Puvis de Chavannes (1824-98) and Rembrandt (1606-69), in whose use of light and dark van Gogh recognized a means of conveying pictorially the illumination that books offered to modern man. In this highly finished drawing (fig. 8) done in Etten in 1881 van Gogh places his reader in a setting typical of The Hague school painter, Josef Israëls, who repeatedly portrayed an old peasant man or woman at the fireside. This setting both conveys the intimacy of the home and expresses the conviction stated in Letter 133, 'One must learn to read, just as one must learn to see and learn to live.'

Throughout his career, van Gogh repeatedly insisted on the validity and necessity of a complete understanding and application of the laws of perspective. To this end he designed his own variations of the traditional mechanical aid, known to Leonardo (1452-1519) and Dürer (1471-1582) and in use in Holland in the nineteenth century, the perspective frame (fig. 10). He relied on this contraption until June 1888, but he could never submit himself entirely to the discipline its use demanded. This accounts for the deviations from geometric Renaissance perspective which came to

8. *Peasant Reading by the Fireplace.* October 1881. Charcoal, watercolour on paper, 44 × 56 cm. (17¾ × 22 in.) Otterlo, Rijksmuseum Kröller-Müller

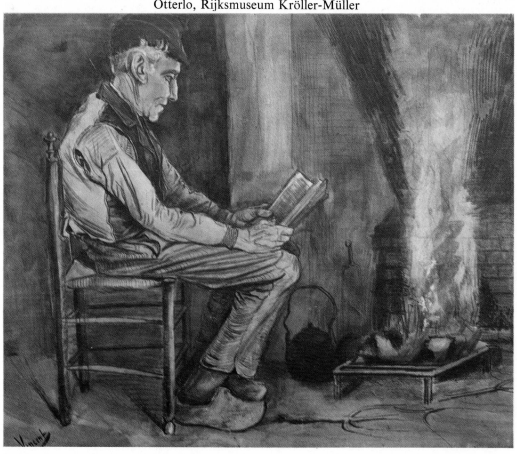

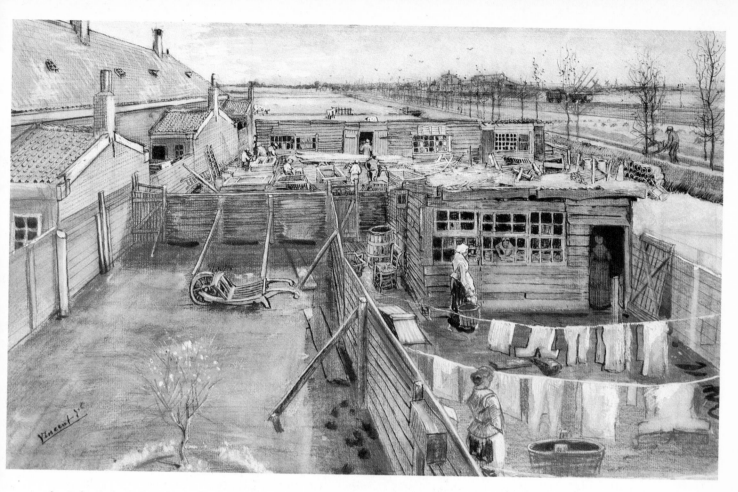

9. *Behind the Schenkweg*. May 1882. Pencil, ink, pen and brush on paper, 28.5 × 47 cm. (11¼ × 18½ in.) Otterlo, Rijksmuseum Kröller-Müller

characterize his work and have given rise to numerous fanciful or psychologistic interpretations. But the divergences from consistent geometric space must be attributed to a contradiction of which van Gogh was at times fully aware. A dialectic worked between his desire to be traditional in his depiction of space, and present a coherent view of the world unified by a single viewpoint, and the impossibility at that date of imposing an artificial unity on a world which he increasingly realized or sensed to be an interrelated totality in constant flux. The drawing of a view of the backyards and outskirts of The Hague (fig. 9), completed to fulfil a commission from his uncle, bears the marks of a rectangular perspective frame he had just had made. As one of the first drawings done with its aid, it shows its more or less rigorous use.

Yet even here it is clear that the whole picture has been seen from various points of view. The landscape speeds into the distance while the foreground expands and dips to embrace the spectator.

10. Sketch of Perspective Frame from Letter 223. August 1882. Amsterdam, National Museum Vincent van Gogh

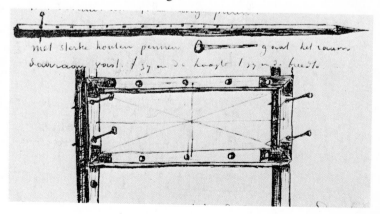

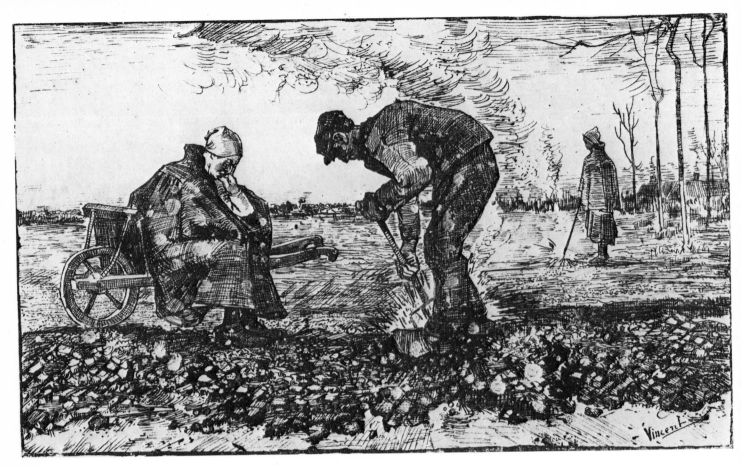

11. *Man Burning Weeds, Woman on a Wheelbarrow.* 1883. Lithograph, 15.5 × 26 cm. (6⅛ × 10¼ in.)
Amsterdam, National Museum Vincent van Gogh

It is significant that van Gogh's experiments with graphic art for a popular market were in lithography and not in the wood engraving technique of the English illustrated magazines. However, in trying to draw appropriately for graphic reproductive processes, he encountered similar problems to those faced by English draughtsmen drawing for woodcuts. As a more direct process of reproduction and a less mechanical one lithography appealed more to van Gogh. In 1883 he heard about a new photographic method of lithography which he believed could revive the now dying art. *Man Burning Weeds* (fig. 11) is an experiment in what was called galvinography, whereby a drawing was transferred photographically to a galvanized zinc plate.

Only two examples of his interest in this new process have survived, for shortly thereafter his orientation as an artist turned more decisively to oil painting and colour.

It is for this rare, precious quality of truthfulness that I delight in many Dutch [seventeenth-century] paintings, which lofty people despise. I find a source of delicious sympathy in these faithful pictures of a monotonous, homely existence, which has been the fate of so many more amongst my fellow mortals than a life of pomp. . . . Neither are picturesque lazaroni or romantic criminals half so frequent as your common labourer, who gets his own bread, and eats it vulgarly but creditably with his own pocket-knife.

GEORGE ELIOT, *Adam Bede* (1858), BOOK II, CH.XVII
(Read by van Gogh, 1875, mentioned in 1877 and 1878)

12. *Man Sitting on a Basket Cutting his Bread.* 1882. Lithograph, 45 × 29 cm. (17¾ × 11⅜ in.) Amsterdam, National Museum Vincent van Gogh

20

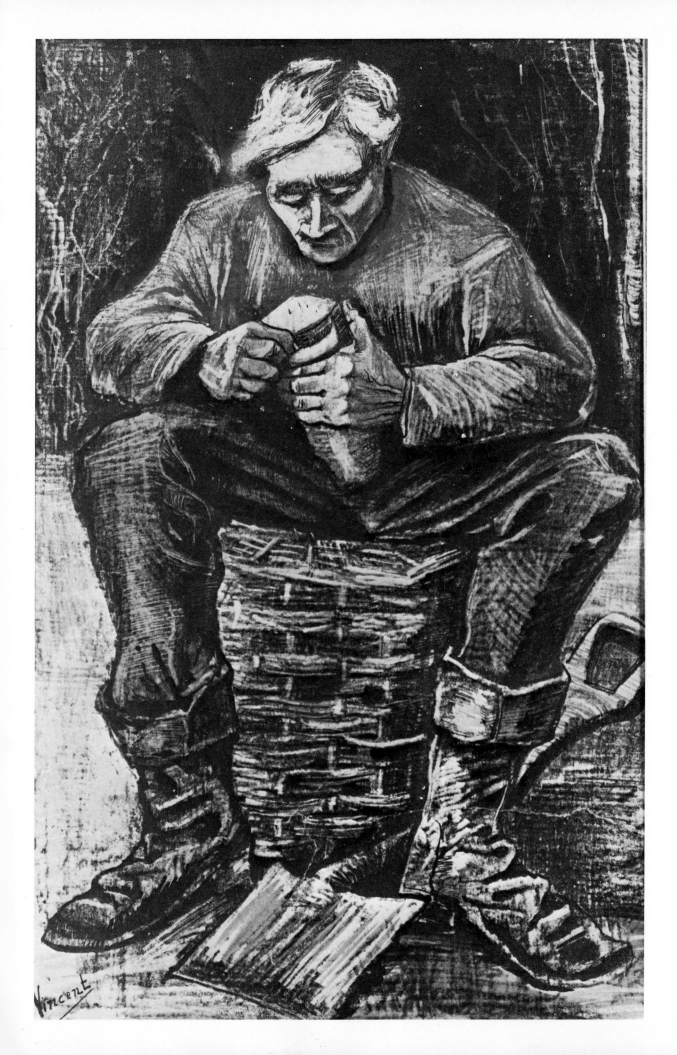

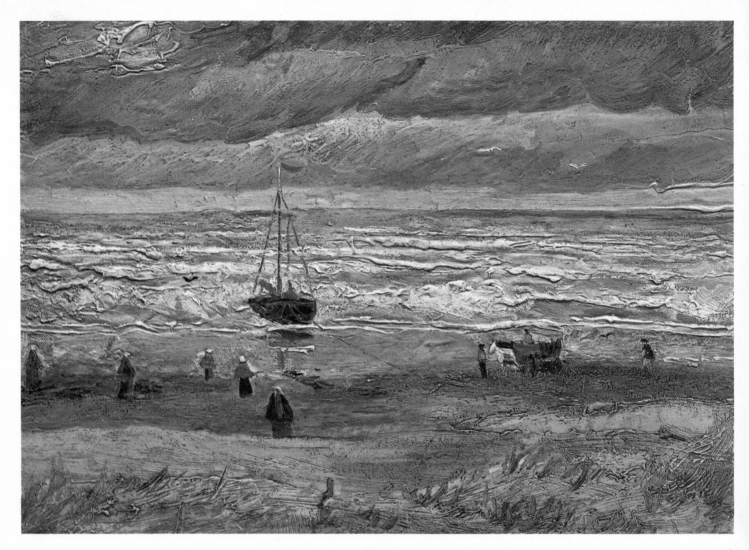

13. *Beach at Scheveningen in Stormy Weather*. August 1882. Oil on canvas on pasteboard, 34.5 × 51 cm. (13⅝ × 20⅛ in.) Amsterdam, Stedelijk Museum

Van Gogh's limited interest in or desire to study oil painting began to change in the summer of 1882 when he discovered to his great surprise, through some studies he did in oil out of doors, that he had a natural feeling for colour. Choosing a motif from the most famous Hague School enterprise, Mesdag's *Panorama* (1881), a huge circular view of the fishing village of Scheveningen, he set up his perspective frame in the dunes on the North Sea coast and produced this small marine painting (fig. 13). The view of the returning fishing smacks, the scurrying figures of the anxious wives and the patiently waiting horses are subordinate to the dramatic atmosphere of the landscape, the glowering, scudding clouds, the stormy sea, which are conveyed by bold strokes and thick paint. The canvas captures the experience of being on the scene rather than merely observing it. Sand is imbedded in the paint surface, witness to the storm in which it was painted. The handling of paint and colour, though crude at times, already indicates van Gogh's later use of painted texture and varied surface to express the world of nature's violence and movement.

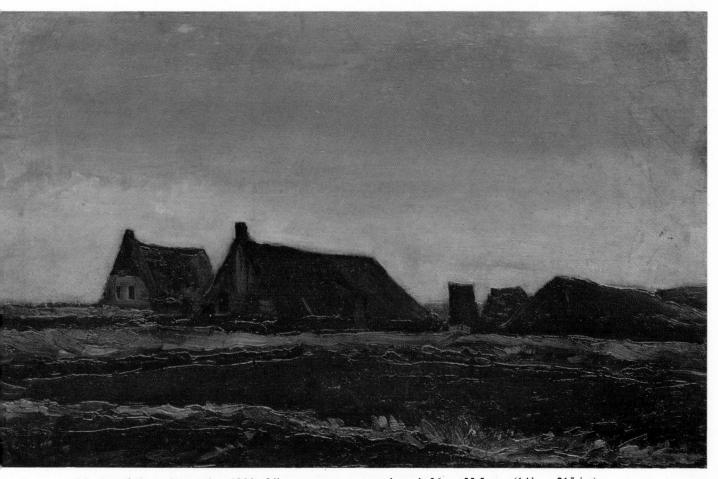

14. *Farmhouses*. September 1883. Oil on canvas on pasteboard, 36 × 55.5 cm. (14⅛ × 21⅞ in.)
Amsterdam, National Museum Vincent van Gogh

A sustained interest in oil painting did not, however, take off until September 1883 when van Gogh abandoned the city and moved to Drenthe, a desolate province in the northern Netherlands where vast moors and peat bogs stretch for miles under huge skies, intersected by canals and dotted with low-walled huts, built into the peat itself and covered with mossy roofs. Although he was only in Drenthe between September and December 1883, these few months are arguably the most formative of his whole career. The letters and pictures produced in Drenthe adumbrate the major themes of his subsequent work, articulate his conception of the artist and indicate his allegiance to nineteenth-century Dutch anarchist thought. A decisive shift is also evident in these months away from the art of the contemporary Hague School to new models. References abound in his letters and pictures to images from an earlier age, from the mid-nineteenth-century community of artists in the French village of Barbizon as well as from the painters of an older Holland, the seventeenth-century forerunners of landscape painting.

23

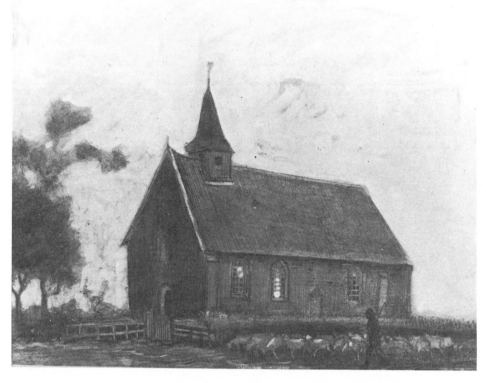

15. *Shepherd with Flock near Church at Zweeloo.* November 1883. Pen and pencil on paper, 25 × 31.5 cm. (9⅞ × 12⅜ in.) Rockanje, R.W. van Hoey Smith

*A cottage made only of sods and turfs and sticks. . . .
I cannot express how their outside looks in the twilight,
or just after sunset, more directly than by reminding
you of a certain picture by Jules Dupré [1811-89] . . .
two cottages, their moss covered roofs standing out
very deep in tone against a hazy, dusky evening sky.
That's the way it is here.
Inside these cottages, dark as a cave, it is very
beautiful.*

(Letter 324)

*In the evening this moor often shows effects which the
English call 'weird' and 'quaint'. Fantastic silhouettes
of the Don Quixote-like mills or curious giants of
drawbridges stand out against the vibrating evening
sky. In the evening such a village, with the reflections
of lighted windows in the water or in the mud puddles,
sometimes looks extremely friendly.*

(Letter 330)

*But in order to grow, one must be rooted in the earth.
So I tell you, take root in the soil of Drenthe—you
will germinate there—don't wither on the sidewalk.
You will say there are plants that grow in the city—
that may be, but you are corn, and your place is in the
cornfield.*

(Letter 336)

*Suppose someone should put the question to you,
would you like to become a painter if you could
suddenly be transferred to the period of forty years
ago, when things were the way they were when Corot
[1796-1875] etc. were young, and if at the same time
you were not alone, but had a companion? The reason
I ask you this is that I am feeling exactly as if I had
been transferred to the above-mentioned period in this
country where progress has got no further than
stagecoach and barge and where every thing is more
untouched than I have seen in any other place.
You have seen Drenthe—from the train, in a hurry,
long ago—but if you come back to the most remote
part of Drenthe, it will make a different impression
on you, you will feel just as if you lived in the time of
van Goyen, Ruysdael, Michel, in short, in what
perhaps one hardly feels even in the present Barbizon.
This is the important thing, I think, for in such natural
surroundings, things can be aroused in a heart, things
which would otherwise never have been awakened. I
mean something of that free cheerful spirit of former
times. . . .*

(Letter 337)

*That coming home of the flock in twilight was the
finale of the symphony I heard yesterday.*

(Letter 349)

24

16. Sketch from Letter 330. October 1883. Amsterdam, National Museum Vincent van Gogh

A sketch (fig. 16) from a Drenthe letter, in which he described the province as miles and miles of Michels (1763-1848), Théodore Rousseaus (1812-67), van Goyens (1596-1656) and de Konincks (1619-88), presents us with subjects that occur in his work right up to 1890—the cottage, the peasant in the fields, fascination with that sign of Dutchness, the drawbridge, the theme of twilight and night scenes, his conviction of man's relation to the earth and his analogy between painting and music.

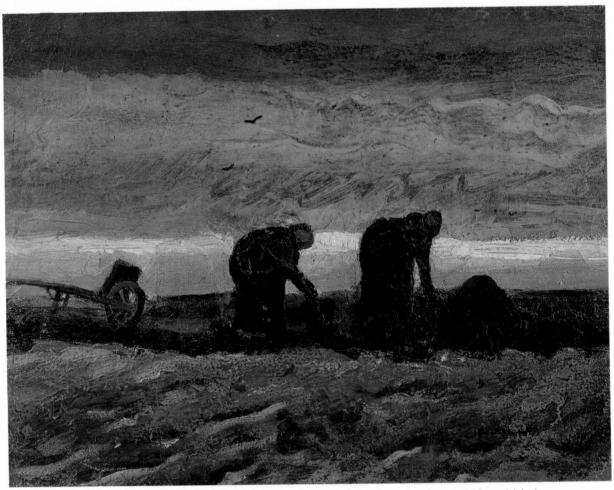

17. *Two Women Digging*. October 1883. Oil on canvas, 27 × 35.5 cm. (10⅝ × 14 in.)
Amsterdam, National Museum Vincent van Gogh

18. *Huts with Thatched Roofs*. March-April 1884. Pen, pencil and ink, 30 × 44 cm. (11⅞ × 17⅜ in.)
London, Tate Gallery

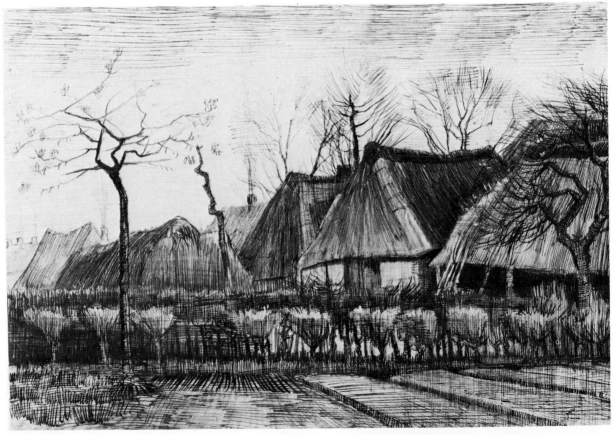

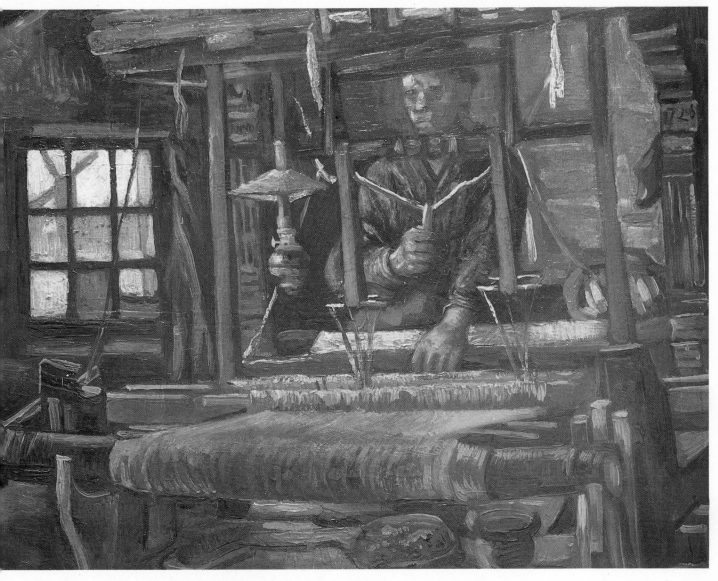

19. *Weaver*. July 1884. Oil on canvas on panel, 48 × 61 cm. (18⅞ × 24 in.)
Rotterdam, Museum Boymans-van Beuningen

In December 1883 van Gogh returned to Brabant, to his father's new vicarage in Nuenen where he remained until November 1885.

But what I wanted to express by it was this: 'When that monstrous black thing of grimed oak with all those sticks is seen in sharp contrast to the grayish atmosphere in which it stands, then there in the centre sits a black ape or goblin or spook that clatters with those sticks from early morning to late at night.' And I indicated that spot by putting in some sort of apparition of weaver. . . .

(Letter to van Rappard 44, April 1884)

Another thing I saw on that excursion was the villages of weavers. The miners and weavers still constitute a race apart from other labourers. . . . I should be happy if one day I could draw them so that those unknown or little known types could be brought before the people. The man from the depth of the abyss—de profundis—that is the miner; the other with his dreamy air, somewhat absent-minded, the somnambulist, that is the weaver.

(Letter 135, September 1880)

27

In the days when the spinning-wheels hummed busily in the farmhouses . . . there might be seen in districts far away among the lanes, or deep in the bosom of the hills, certain pallid, undersized men, who, by the side of the brawny country folk looked like the remnants of a disinherited race.

GEORGE ELIOT *Silas Marner—The Weaver of Raveloe* (1861), BOOK I, CH. I

20. *Weaver*. May 1884. Oil on canvas, 70 × 85 cm. (27½ × 33½ in.) Otterlo, Rijksmuseum Kröller-Müller

28

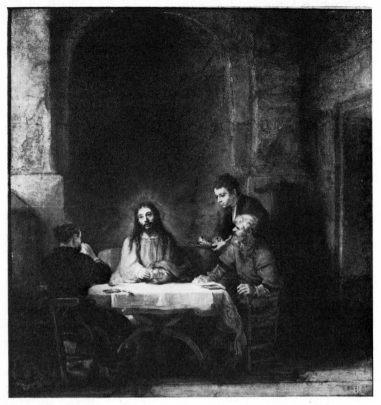

21. Rembrandt van Rijn: *The Supper at Emmaus*. 1648. Oil on panel, 68 × 45 cm. (26¾ × 17¾ in.) Paris, Louvre

I have tried to emphasize that those people eating their potatoes in the lamplight, have dug the earth with those very hands they put into the dish and so it speaks of manual labour and how they have honestly earned their food.

(Letter 404)

The colour and the atmosphere it evokes was intended to make the painting a 'real peasant picture'. The peasants are painted the colour of a dusty, unpeeled potato and the whole scene was meant to exude an odour of bacon and smoke. Van Gogh wanted to assault all the senses of the spectator. To ensure the depth of colour, and remind the viewer of the warm glow of the friendly lamp he suggested that the picture be placed in a golden frame.

According to van Gogh, the picture came from the heart of peasant life, to celebrate their closeness to the earth, a timeless daily ritual, and the honesty of manual work, however small its rewards in material terms. Such a scene was none the less very common amongst Hague School painters, especially Josef Israëls, whose portrayals of peasants' mealtimes emphasized bourgeois concerns with the virtues of home and the family. But van Gogh's *Potato Eaters* goes far beyond genre, beyond bourgeois realism. It incorporates a message van Gogh took from Millet, that modern art should use themes from peasant life to convey old religious feelings in secular terms. Van Gogh saw that Millet did not paint the figure of Christ, but His doctrine and especially the Biblical injunction to earn bread by the sweat of one's brow.

One can cite a more directly religious source in the obviously intended reference to a painting long beloved by van Gogh, Rembrandt's *Supper at Emmaus* (fig. 21), which commemorated the simple meal at which Christ, resurrected, revealed himself in a glow of light to two disciples. However, van Gogh's image, stripped of all religious iconography, save for the crucifix on the wall, synthesizes

In the Nuenen period van Gogh's long-standing admiration for the French painter Jean François Millet as the peasant painter and painter of peasants flourished into a virtual identification with the artist, his life and subject-matter. He wrote to Theo in 1885, 'When I call myself a peasant painter, it is a real fact' (Letter 400). The intensity of his identification with the Catholic Brabant peasant is akin to his involvement with the miners of the Borinage. His continual drawing and painting of these peasants culminated in his first major subject composition in oil, the *Potato Eaters*, April 1885 (fig. 22).

Reworking his concern with light in darkness, the painting shows a family in a darkened interior illuminated by a central, hanging old-fashioned lamp. The peasants have just begun their daily meal of potatoes and coffee,

30

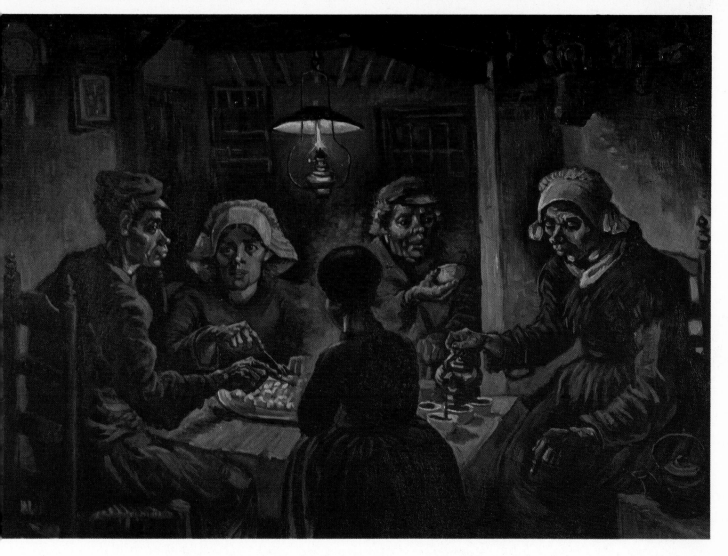

22. *Potato Eaters*, April 1885. Oil on canvas, 82 × 114 cm. (32¼ × 44⅞ in.)
Amsterdam, National Museum Vincent van Gogh

these different sources, Israëls, Millet and Rembrandt, and effects a transformation of peasant genre to produce a modern religious painting. Yet, as with the 'Bearers of the Burden' (fig. 2), the religious connotations are not conventional, and indeed, the ultimate source for its complex of meanings lies entirely outside the Bible or any religious text. It is once again the imagery and ideas of Carlyle's *Sartor Resartus* which provide a key to the contradictory messages of this striking image of poverty, faith, dignity and, in the tension of the composition, a powerful feeling of unease. In the final chapters of that essay, Carlyle schematically divides unsettled modern society into the two conflicting classes; the Dandies, the conventional and superficial, and the Poor Slaves. We quote from his description of that class beneath the painting by van Gogh, leaving the words to speak for themselves.

One might fancy them worshippers of Hertha, or the Earth: for they dig and affectionately work continually in her bosom; or else shut up in private Oratories, meditate and manipulate the substances derived from her. . . .

In respect of diet, they also have their observances. All Poor Slaves are Rhizophagous [root eaters]. . . . *Their universal sustenance is the root named potato, cooked by fire alone.*

THOMAS CARLYLE, *Sartor Resartus*, BOOK III, CH. X

31

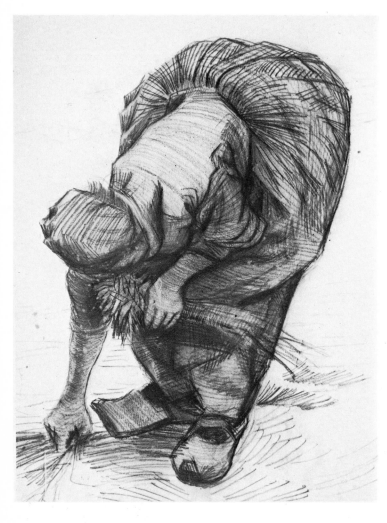

23. *Peasant Woman Gleaning*. August 1885. Black chalk on paper, 51.5 × 41.5 cm. (20¼ × 16⅜ in.) Essen, Folkwang Museum

In answer to the severe criticism of his figure style in the *Potato Eaters* made by a fellow Dutch artist, Anthon van Rappard (1858-92), van Gogh produced some of the finest drawings he ever did. They were intended to justify him in invoking the name of Millet in relation to his own work and many use that artist's most typical motifs (fig. 23). However, their impact is entirely different. There is a studied crudeness or roughness in the draughtsmanship and an exaggerated bulkiness in the figures as they bend inexorably towards the earth.

A long-standing point of contention between van Gogh and van Rappard was the importance of correct technique. Van Gogh constantly searched for a style to fit his subjects, to find appropriate visual or pictorial equivalents in the kinds of marks he made and the medium used to convey a sense of the substantial presence and the material life of his figures and the integration of man into nature, in this instance in a chalk drawing of a peasant at work with the land. This necessity may account for the variety of techniques and changes of style that occur in his work over a decade—a diversity of appearances produced in response to an underlying thematic unity, namely the need to assert a specific and increasingly anachronistic view of the necessary relations between man and the earth.

Within a few months of this total commitment to peasant life as the core of modern art, we witness the beginnings of an apparent change of emphasis. Feeling a renewed need to get closer to the centre of *avant-garde* art and be among artists and pictures, van Gogh left the country and moved to the city, Antwerp, a step closer to and a necessary preparation for his ultimate destination, Paris. His notion of modernity was shifting and this reorientation was adumbrated in a still-life (fig. 24 and compare fig. 26) done just before he left Nuenen in October 1885. The opened

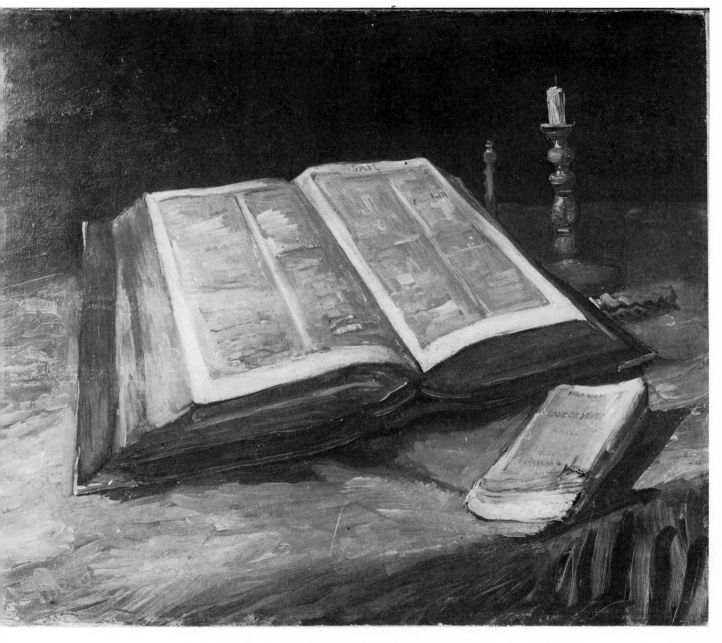

24. *Still-life with Open Bible.* October 1885. Oil on canvas, 65 × 78 cm. (25⅝ × 30¾ in.)
Amsterdam, National Museum Vincent van Gogh

pages of the Bible are juxtaposed to the bright yellow covers of a modern French novel, Emile Zola's *Joie de Vivre*. It has been argued that the painting thus proposes the literature of modern reality in place of the old religion of the Bible. Yet the choice of Zola's most profoundly pessimistic novel out of the many he had read by that author, and the decision to open the Bible at Isaiah 53, 'he was a man of sorrows and acquainted with grief,' suggests less a virulent opposition than a transposition, and serves as a manifesto of his commitment to contemporary forms of literature and art.

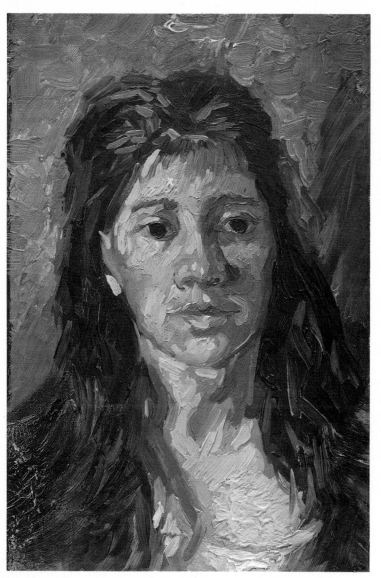

The pictures that van Gogh did in Antwerp (November 1885 to February 1886) were not painted in the same manner as those he had executed in rural Nuenen. His relationship with the Belgian port and its inhabitants and their relationship with the world were different. In Antwerp van Gogh made the transition from peasant painter to city painter, haunting the café-concerts, the dance halls, the docks and the public squares. He was helped in this by an attentive analysis of the paintings of Frans Hals (1580/5-1666), whose paintings suggested certain ways in which he could adapt his coloration and technique to a different type of environment, a different type of person, and above all, a different sense of life, new, shifting, transient and rootless. In *Head of a Woman* (fig. 25), of December 1885, the solidity of his heavy Nuenen brushwork has given way to a shorter, more nervous touch, and the dominant tonality of earth colours that symbolically linked the peasant to the soil is replaced by a more luminous palette based on complementary colour.

25. *Head of a Woman*. December 1885. Oil on canvas, 35 × 24 cm. (13¾ × 9½ in.) Amsterdam, National Museum Vincent van Gogh

26. *Still-life with Plaster Statuette and Books*. Autumn 1887. Oil on canvas, 55 × 46.5 cm. (21⅝ × 18¼ in.) Otterlo, Rijksmuseum Kröller-Müller

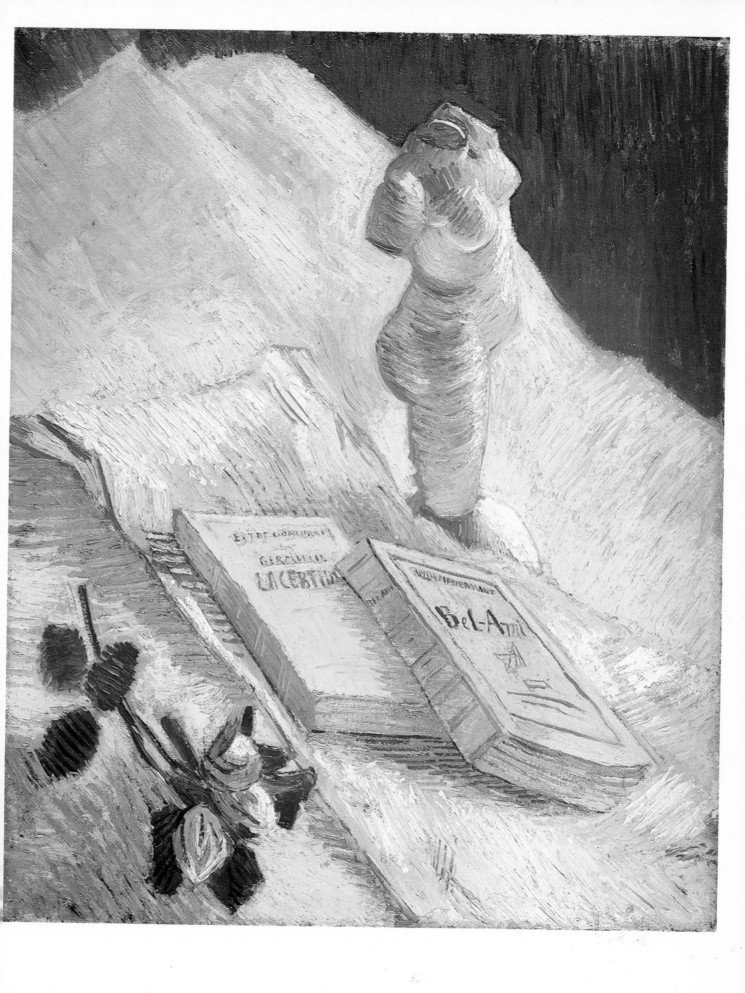

It was in Antwerp that van Gogh first mentioned owning Japanese prints. He probably purchased them on his arrival in the city, which had been host to the Exposition Universelle since May 1885, at which Japan had been well represented. Japanese goods were readily and cheaply available in the port's shops and bazaars. But why had van Gogh bought the prints then? In the latter months of 1885 he had read de Goncourt's novel *Chérie* (1884), in the preface to which the author had claimed that he and his brother had been responsible for the three most important aesthetic movements of the nineteenth century, *la recherche du vrai en littérature, la résurrection de l'art du XVIII ième siècle, la victoire du Japonisme*. It was under this influence that van Gogh decorated his studio with Japanese prints. From another work by the de Goncourts he quoted their phrase 'Japonaiserie Forever', borrowing this slogan to substantiate his comparison of the Antwerp quays with scenes he saw in the Japanese prints. Having already embraced the search for modern reality and discussed the revival of eighteenth-century art, he now espoused an interest in the third movement, *Japonisme*. In doing so, he tried to make clear to his brother, Theo, that he was a truly modern artist, someone well-prepared to take his place in the artistic milieu of Paris.

In March 1886 van Gogh arrived unexpectedly in Paris, where, for two years, he attempted to come to terms with modern French art. But the scene that confronted him in Paris was one of great flux, change and bitter division between different sects jostling for pre-eminence in the space created by the decline of the now discredited Impressionism. 1886 witnessed the last group show of the Impressionists, from which Monet (1846-1926) and Renoir (1814-1919) were significantly absent, as well as the announcement of a new movement, dubbed Neo-impressionism, at the second exhibition of the Indépendants. At this Georges Seurat's (1859-91) *La Grande Jatte* (Chicago Art Institute) took pride of place as a manifesto of a new rigorous, scientific procedure and an interest in a very different aspect of the urban scene than that depicted by what Pissarro (1831-1903), a convert to the new style, called disparagingly 'the romantic impressionists', out of keeping with 'the spirit of the times'. The Symbolist movement declared itself with the publication of the writer Jean Moréas's *Manifesto of Symbolism*, while new musical attitudes developed under the influence of concerts of Wagner's music. With the foundation of the *Revue Wagnerienne* poets and artists began to explore the music of this composer as a model for a new kind of art.

It is undeniable that in his two years in Paris van Gogh took note of the current trends and experimented briefly with their different procedures, for painting out of doors, for creating greater luminosity, for organizing a picture surface more systematically. At times some of his suburban or industrial motifs bear comparison with Impressionist or Neo-impressionist modes. But it is equally clear that he could not fully endorse what he learnt about French art or situate himself in this conflict-riven community.

For these reasons, one can detect very little change in his work from the late Antwerp pictures for the first nine months of his stay, during which he improved his figure drawing with studies of plaster casts and the nude at the fashionable studio of Fernand Cormon, studied Delacroix's paintings for hints about a colour theory he had already discovered while in Nuenen and, in a style derived from a little-known Provençal artist, Adolphe Monticelli (1824-86), painted a mass of flower studies in order to consolidate his concern for brilliant colour. A brief flirtation

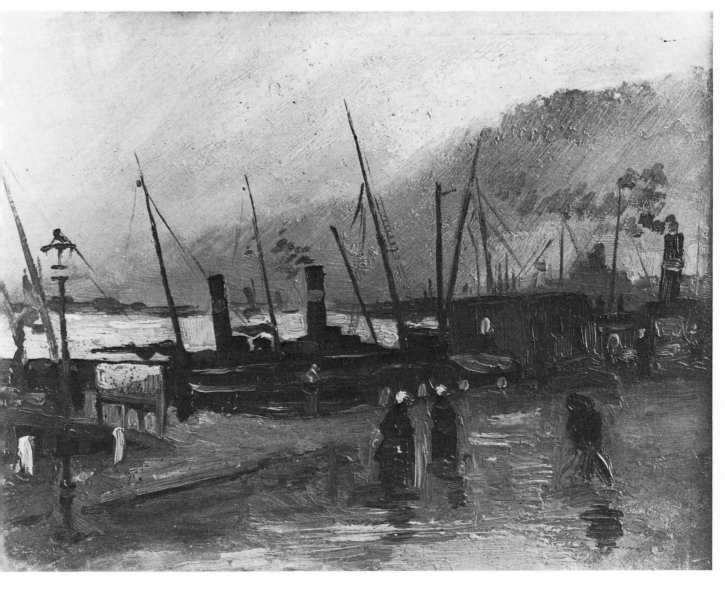

27. *The Antwerp Quay*. December 1885. Oil on panel, 20.5 × 27 cm. ($8\frac{1}{8}$ × $10\frac{5}{8}$ in.)
Amsterdam. National Museum Vincent van Gogh

with Impressionism occurs in the winter of 1886-7, but his access to its principles came second-hand through other expatriot students, notably the Australian who had worked with Monet, John Russell (1858-1931). It was not until well into 1887 that van Gogh met Pissarro and Signac (1863-1935), advocates of Neo-impressionism, or began to work with a young artist Emile Bernard (1868-1941), whose disaffection from existing movements was leading him in a very different direction, *cloisonnisme* and later, synthetism.

Van Gogh tried to take his place in this sophisticated urban milieu. Some self-portraits (fig. 29) show him spruce in his city suit, collar and tie, dashing felt hat; his health restored, his teeth attended to and his beard neatly trimmed. But later in 1887 he rejected this bourgeois dress, donned a workman's blue jacket and the hobnailed boots which we

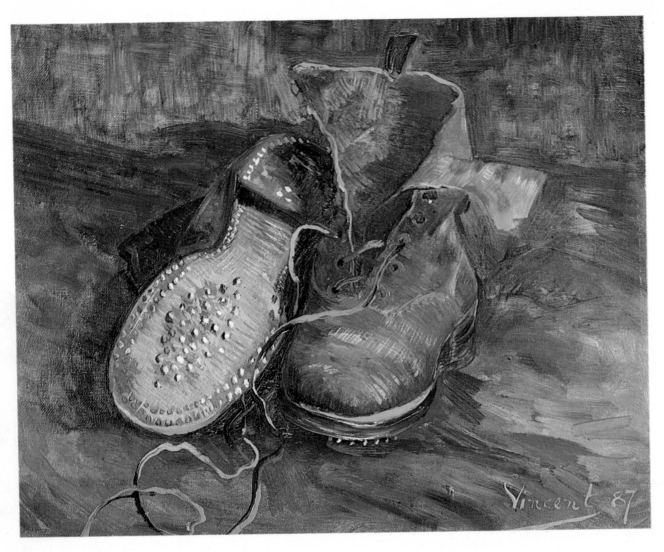

28. *Boots*. Autumn 1887. Oil on canvas, 34 × 41.5 cm. (13⅜ × 16⅜ in.) Baltimore, Museum of Art

see in an indirect self-portrait, a beautiful study of these solid workman's boots (fig. 28).

In short, we may presume that his ambition to come to Paris was not based on a clear idea of what he wanted from it. It took him a year and a half to realize that he did not want what it had to offer. Although when he left he had been enriched by his acquaintance with certain people, artists, like Russell, Bernard, Gauguin (1848-1903) and art dealers like Père Tanguy (fig. 32), and affected by his encounter with certain new ideas, which, in the end, served to validate the convictions about art

29. *Self-portrait with Grey Felt Hat*. Summer-Autumn 1887. Oil on canvas, 44 × 37.5 cm. (17⅞ × 14¾ in.) Amsterdam, National Museum Vincent van Gogh

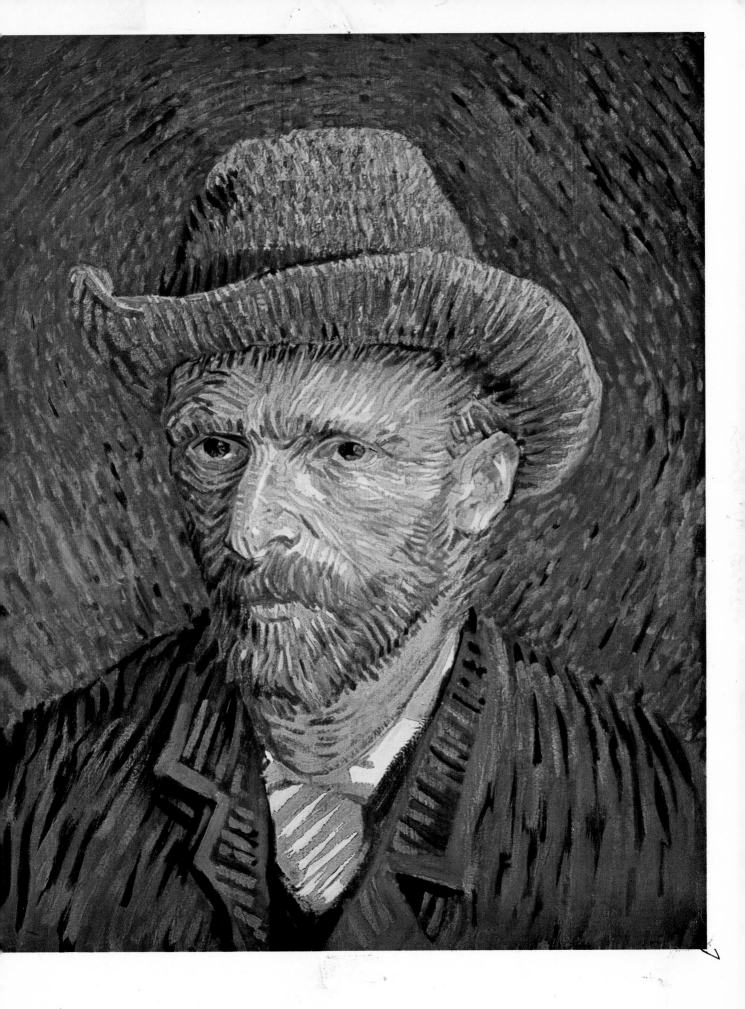

that he had brought with him. In a letter written a few months after his arrival in the South of France, whither he had gone in February 1888, he wrote to Theo,

It is only that what I learned in Paris is leaving me, and I am returning to the ideas I had in the country before I knew the Impressionists. And I should not be surprised if the Impressionists soon find fault with my way of working, for it has been fertilized by Delacroix's ideas rather than by theirs. Because instead of trying to reproduce exactly what I have before my eyes, I use colour more arbitrarily, in order to express myself more forcibly.

(Letter 520; van Gogh uses the term 'Impressionist' here to refer to all contemporary French artists.)

Thus the most important questions raised by the Paris period are why did he leave to go south and what did he mean by the 'arbitrary' use of colour?

A discussion of van Gogh's uneven interest in Japanese prints in the Paris years provides some answers. Despite the popularity of Japanese prints in Paris, there is no evidence that the interest he had shown in them while in Antwerp was sustained in his first year in the French capital. It was probably his friend John Russell (1858-1931), who was painting a portrait of van Gogh in late 1886 (fig. 30), who drew his attention to the prints from a pictorial point of view, and probably explained how important they had been to the Impressionists and were for a thorough understanding of modern art. Van Gogh began to buy Japanese prints systematically and in March 1887 exhibited his collection at the Café Tambourin. Yet no direct debt to them is evidenced in his work even in the first half of that year. His reawakened interest in the prints and a growing awareness of their potential, if still obscure, relevance to his art, coincided with a period of personal crisis – difficulties with Theo, the painful collapse of a love-affair. There is reasonable evidence to

suggest that in the summer of 1887 he experienced some kind of breakdown.

His serious interest in the prints can be dated to late summer 1887 and extending from August to December, culminating in a series of direct copies of prints and their inclusion in the background of certain portraits (fig. 32). It would seem that the rich, saturated colour and textured surfaces of a certain type of print offered him solutions to the pictorial problems he had been grappling with since 1885 in his study of Hals, Delacroix and the Provençal artist, Adolphe Monticelli. He began to produce paintings in which his brushwork was systematically organized and the colour achieved a greater freedom and boldness. It is of much greater importance, however, that in his state of personal crisis and sense of alienation from both Paris and its artists, van Gogh began to see the prints as depictions of a beautiful, sun-filled, harmonious world. This world could offer him the imaginary solace that, as early as 1880 in an earlier period of crisis, he had projected on to 'the land of pictures'. But the difference in 1887 was that he had come to believe that the renovation or renaissance of modern art would only take place away from the city, the symbol of a decadent and diseased society. His search for a world of harmonious relations in which man belonged happily to a fruitful, natural world found confirmation in his conception of Japan derived in part from the prints. Although there is almost no direct influence of the prints' typical devices of line, flat colour and oriental perspective, they did give him confidence to use colour more brilliantly and arbitrarily.

The portrait of his friend, the colour merchant and art dealer, Julien Tanguy (fig. 32), completed late 1887 to early 1888, has all the force of a manifesto. Despite the inclusion of painted copies of identifiable prints as a screen against which Tanguy is

set, any distinctive features that would indicate influence from the prints are conspicuous by their absence. It is precisely the total absence of line, the bounding black contour, the graphic marks used to vary the surface of printed colour, as well as alteration of perspective that reveal the crucial difference between van Gogh's mature style and that of his French contemporaries who were indeed influenced by Japanese woodcuts. He was not interested in using in his work unusual compositional devices or in drawing on Japan as a source of exotic props. So why are these prints placed behind Père Tanguy? Precisely because the prints are treated in an entirely painterly fashion, attention is drawn to what they depict and not to the stylistic character of the woodcuts. Interesting oppositions are set up by van Gogh's selection of prints—between season, winter on the left and spring on the right; between people and landscape, by the pair of figure subjects that are placed below them. The lowest level offers a decorative panel and a small study of flowers against a landscape. These in fact adumbrate the motifs that van Gogh pursued after he left Paris for the South of France and which he justified by arguing that the future of modern art lay in the portrait and establishing the place of man in relation to nature.

The figure of Tanguy himself is placed firmly, centrally and monumentally into this pictorial world. A relationship is established between the idealized landscapes and people, and this man, in his rough, workman's clothes, admired by van Gogh as a representative of a new world. Tanguy was a republican in his politics, a supporter of *avant-garde* art and a fellow fighter in the struggle against a commercialized and dehumanized society. The whole composition is unified by systematic patterning of brushwork which describes the various textures. It bespeaks van Gogh's complete confidence in

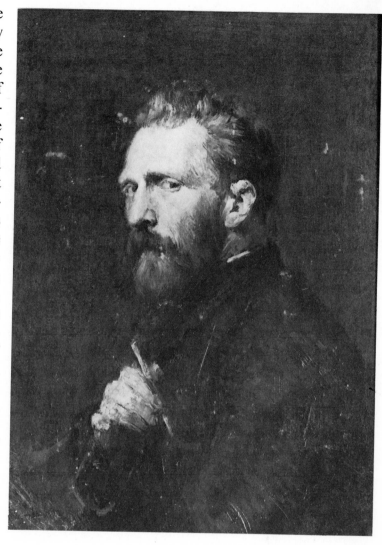

30. John Russell (1858–1931): *Portrait of Vincent van Gogh*. Winter 1886. Oil on canvas, 60 × 45 cm. (23⅝ × 17¾ in.) Amsterdam, National Museum Vincent van Gogh

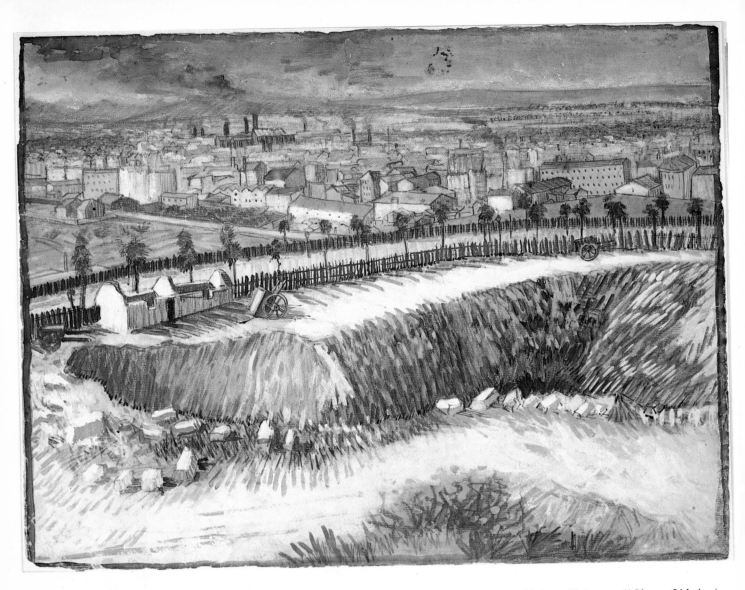

31. *Outskirts of Paris near Montmartre.* Summer 1887. Watercolour on paper, 39.5 × 53.5 cm. (15½ × 21⅛ in.)
Amsterdam, National Museum Vincent van Gogh

his art and his command of the necessary means of realization.

In a beautiful watercolour of 1887 (fig. 31), van Gogh looks out across Clichy, across the smoking, industrial suburbs of Paris, dominated by chimneys to a distant view of the hills. The drawing depicts the point where the city meets the country. In the foreground a little, still countrified lane marks the frontier, while beside a pit from which the stones used for building the new, growing Paris were quarried, van Gogh tenderly draws

an old hand cart, the type that gave its name to a painting and related drawings which he painted in the productive summer in the Provençal countryside, whither he moved in February 1888 (figs. 33 and 34).

32. *Portrait of Père Tanguy.* Winter 1887–8. Oil on canvas, 92 × 75 cm. (36¼ × 29½ in.) Paris, Musée Rodin

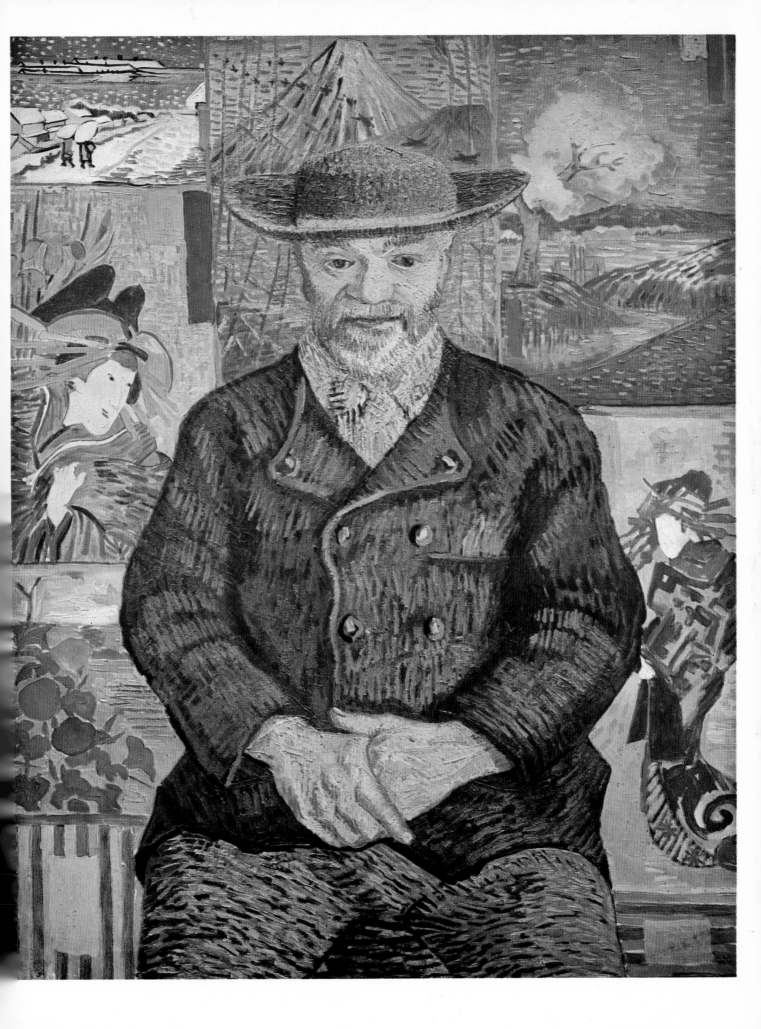

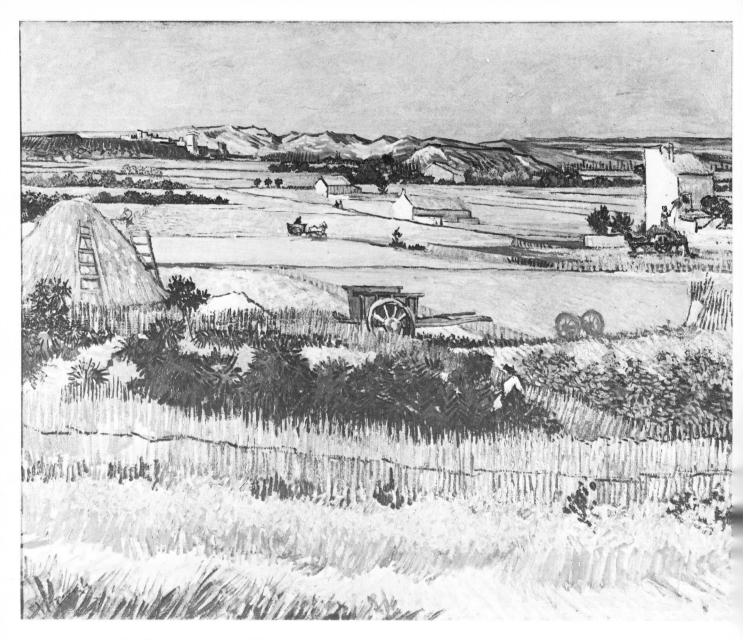

33. *Harvest at La Crau* ('*The Blue Cart*'). June 1888. Oil on canvas, 72.5 × 92 cm. (28½ × 36¼ in.)
Amsterdam, National Museum Vincent van Gogh

In 1884, while still in Nuenen, van Gogh expressed the desire to paint a series of the seasons in complementary colour pairs (Letter 372). In the first six months in Arles he fulfilled that ambition and *Harvest at La Crau* (fig. 33), also known as *The Blue Cart*, is painted in rich oranges and blues, the pair connoting summer. From the moment he arrived in the South, van Gogh repeatedly stressed to his correspondents how he felt that he had arrived in his Japan. But this vast panoramic landscape of the great plain of the Crau near Arles with the ruined abbey of Montmajour and the Alpilles in the background bespeaks another, occidental homeland—Holland. However, it was an equally idealized Holland, seen through the paintings of the seventeenth century, by Ruysdael, de

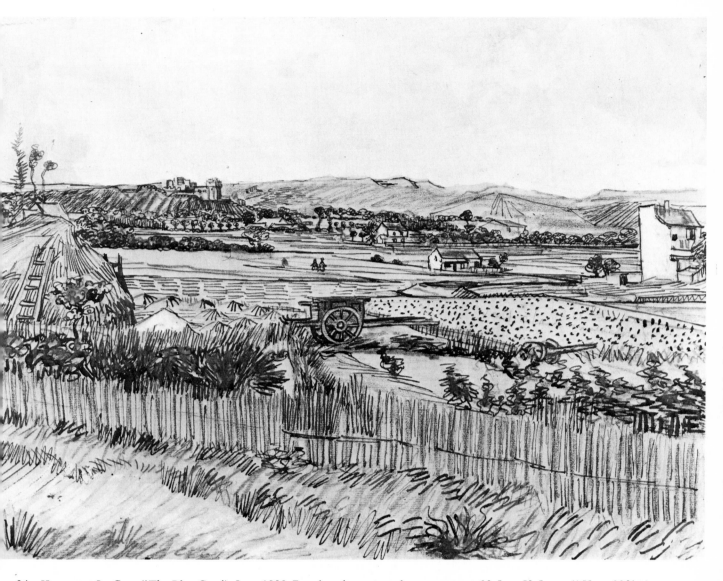

34. *Harvest at La Crau* ('*The Blue Cart*'). June 1888. Pen, brush, watercolour on paper, 39.5 × 52.5 cm. (15⅜ × 20¾in.)
Cambridge, Massachussetts, Fogg Art Museum

Koninck and Hobbema—names which recur throughout the letters of this period when he tries to suggest the landscape that he is seeing. This painting of the Crau (fig. 33) was an important work. Van Gogh made drawings in preparation for it (fig. 34) and drawings after it to send to friends. The differences between the oil and the drawing are significant. In the finished oil, the scale of the view is greater, the landscape more panoramic. He has multiplied the figures who help to punctuate the more extended space. They are more active — travelling, reaping, building haystacks; but these figures are dwarfed by the landscape and integrated into the world they inhabit and work.

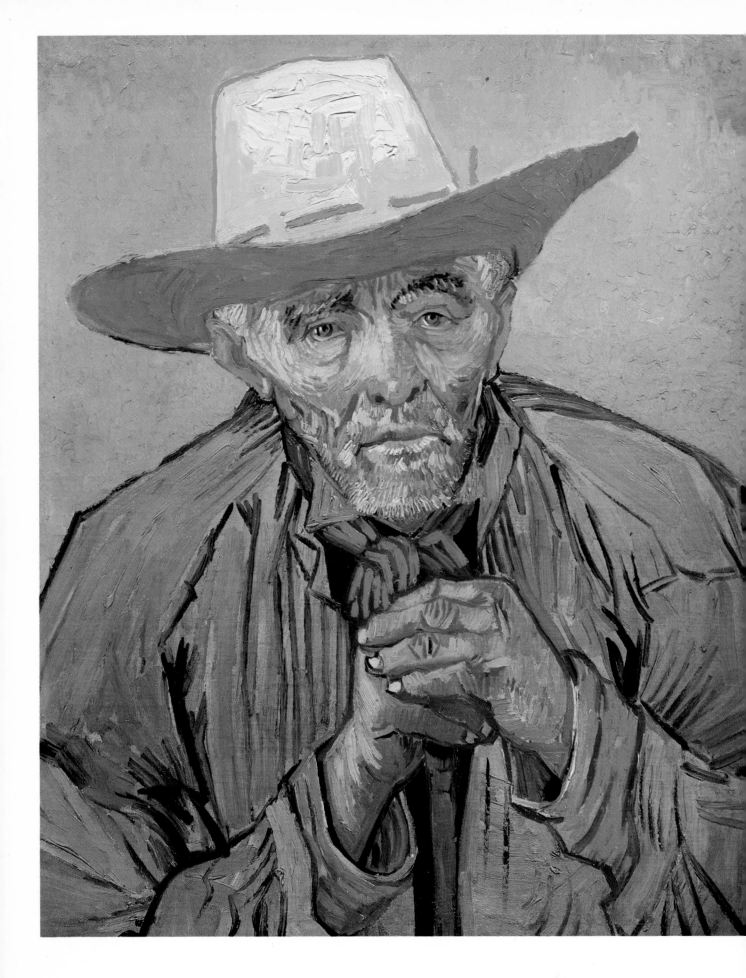

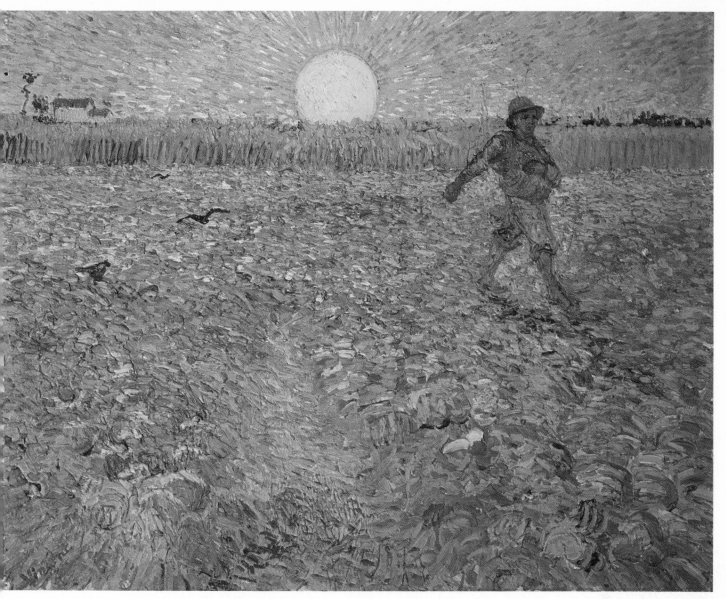

36A. *The Sower*. June 1888. Oil on canvas, 64 × 80.5 cm. (25⅛ × 31⅝ in.)
Otterlo, Rijksmuseum Kröller-Müller

Par le crépuscule et le hâle
Le paysan deux fois bruni.

(The peasant, twice burnished by the twilight and the blaze of the sun.)

(Quoted Letter 406, May 1885)

I imagine the man I have to paint, terrible in the furnace of the heat of harvest-time, as surrounded by the whole Midi.

(Letter 520, August 1888).

35. *Portrait of Patience Escalier*. August 1888. Oil on canvas, 69 × 56 cm. (27⅛ × 22¼ in.) Stavros S. Niarchos Collection

We've read La Terre [Zola, 1887] *and* Germinal [1884] *and if we are painting a peasant, we want to show that in the end, what we have read has come very near to being part of us.*

(Letter 520, August 1888)

Ah! I have another figure all the same which is the absolute continuation of certain studies of heads I did in Holland. I showed them to you one day with a picture from that period: The Potato Eaters, *I wish I could show you this one.*

(Letter to Bernard 15, August 1888)

47

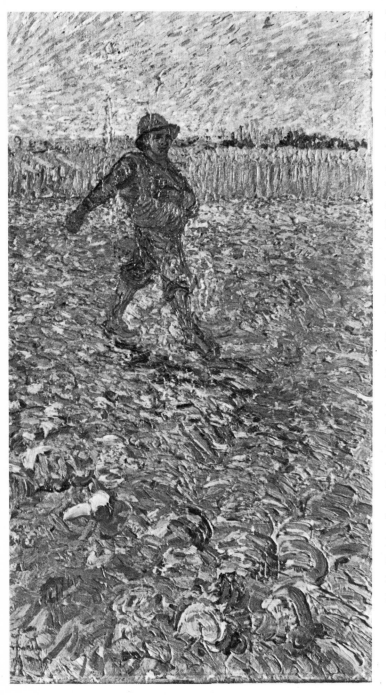

The fiery furnace of the Midi that van Gogh evokes by the saturated red background of the portrait of Escalier finds a radically different expression in a drawing of Arles from the wheatfields (fig. 37), where we can see his expanding graphic vocabulary at work. The whole surface of the paper is filled with a variety of marks, which describe form, evoke colour, and activate the space of the sky. From this date on in van Gogh's drawings, space becomes a real, material substance. Like Cézanne, van Gogh rejected the old opposition of form versus void and with it the notion of space as empty. He seems to have sensed what Georges Braque (1882-1963) was later to call a 'manual', 'tactile' space. In van Gogh's works, solid and space have equal force and at the same time, by the same process of pen marks on paper the figures are inseparable from their environment.

The scene van Gogh has chosen to depict here once again focuses on the meeting of the city and the country. The perspective, looking up to a chimneyed skyline gives a different view of that frontier from his Paris drawing (fig. 31). It plunges the spectator into the wheatfields, where two peasants are reaping. The city and the countryside meet at the railway line, yet the little train is not only a sign of modern industrial society, but a symbol itself of a new network of connections the railway established.

36B. Detail of *The Sower* (Plate 36A)

37. *Arles: View from the Wheatfields.* Summer 1888. Pen and ink, 31.5 × 24 cm. (12¼ × 9⅛ in.) Formerly Basle, Robert von Hirsch

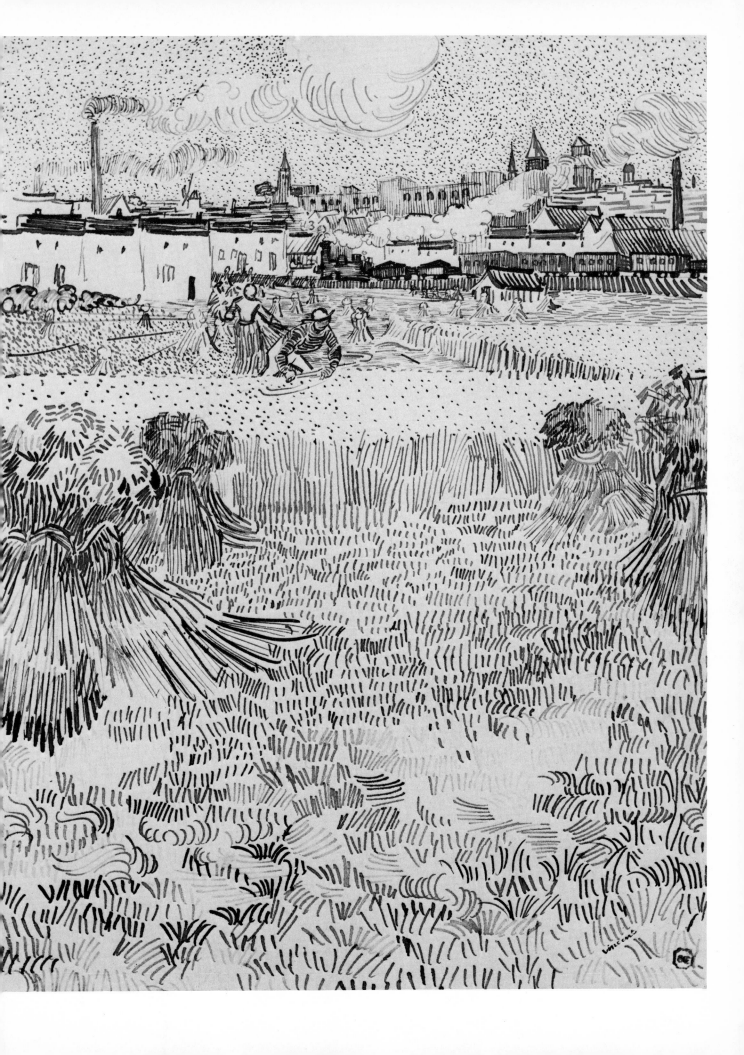

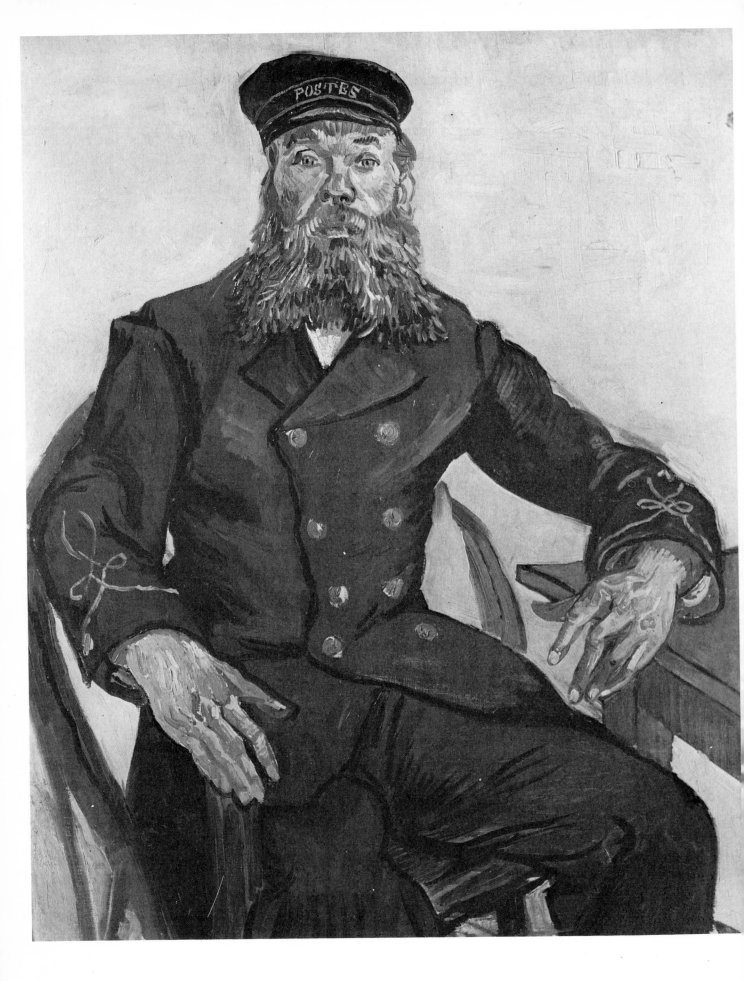

In Arles van Gogh made the acquaintance of the postman, Joseph Roulin and his family, of whom he painted a series of portraits in late 1888. In the portrait, as van Gogh understood it, not as mere likeness but more as a representative type, lay the future of modern art. In the Roulin series he illustrated the allegiance to the example of Dutch seventeenth-century portraitists that he proclaimed so insistently in his letters to Emile Bernard at this time. 'I am just trying to make you see the great, simple thing: the painting of humanity, or rather, of a whole republic, by the simple means of portraiture' (Letter to Bernard 13, August 1888). Armand Roulin (fig. 39) in fact takes his pose, his rakish hat, his painterly handling from a painting by Hals, *The Merry Drinker* (Amsterdam, Rijksmuseum), before which van Gogh had made an attentive study in October 1885. But the seriousness of the expression and the contemporary dress exceed a simple, but intended homage to Hals and proffer a portrait of modern man.

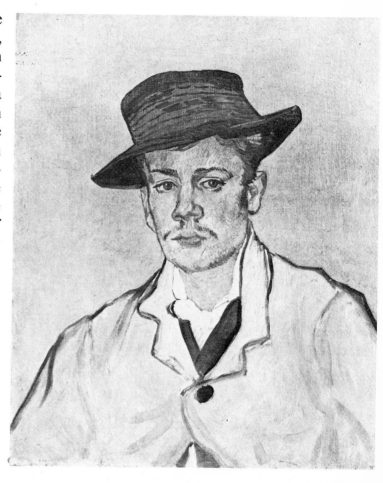

I do not know if I can paint the postman as I feel him; this man is like old Tanguy in so far as he is a revolutionary, he is probably considered a good republican because he heartily detests the republic which we now enjoy, and because he is beginning to doubt and is somewhat disillusioned with the republican principle itself. I saw him one day singing the Marseillaise, and I thought I was watching '89, not next year, but the one ninety-nine years ago. It was from Delacroix, from Daumier, straight from the old Dutchmen.

(Letter 520, August 1888)

38. *Portrait of the Postman Joseph Roulin.* August 1888. Oil on canvas, 81 × 65 cm. (31 × 25½ in.) Boston, Museum of Fine Arts

39. *Portrait of Armand Roulin.* November 1888. Oil on canvas, 66 × 55 cm. (26⅛ × 21½ in.) Essen, Museum Folkwang

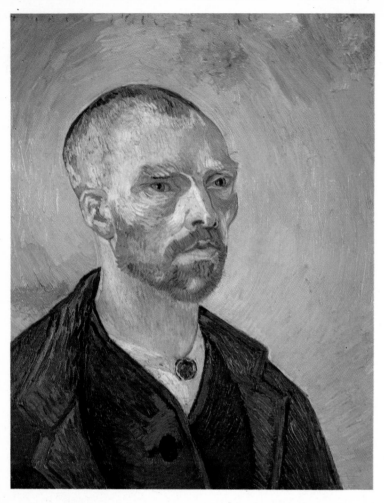

40. *Self-portrait Dedicated to Paul Gauguin.* September 1888. Oil on canvas, 62 × 52 cm. (24½ × 20½ in.) Cambridge, Massachussetts, Fogg Art Museum

Van Gogh's interest in the oppositions of light and dark led to an interest in night scenes, the opposite of brilliant daylight. In Arles he painted a picture of one of the all-night haunts of the down and outs and those who worked by night, the prostitutes, *The Night Café* (New Haven, Yale University Art Gallery), an alternative name of which in French is *l'Assomoir*, the title of a novel by Emile Zola (1877). But in the more uptown *Café Terrace at Night* (fig. 41) he showed a more cheerful scene, using saturated yellows and deep blues to convey the way artificial illumination could transform the night. Moreover he contrasts the glare of the gas lights with the friendly, natural light of stars in the night sky. The star is a frequent image in van

Gogh's letters and he endowed it with profound symbolism. The presence of the stars here are beneficent, their grouping underlining the happy companionship of the couples seated below at the café's tables.

Van Gogh undertook this *Self-portrait* (fig. 40) to exchange with portraits by a group of artists working in Brittany, in Pont Aven, led by Emile Bernard and Paul Gauguin. His long-standing dream of a cooperative community of artists and his conviction that a renaissance of art could only take place in the sun, the South or the Tropics resolved itself into a plan for a studio of the South based in Arles. He was at this time pressing Gauguin to come and join him in Provence.

Using himself as a model van Gogh painted his conception of the artist, as a modern, secular saint. A brilliant green background is brushed into radiating, halo-like circles behind his monkishly shaven head and the dark-brown, rough textured jacket takes up this reference. The eyes slant upwards, a feature explained by a letter to Gauguin where van Gogh stated, 'I have in the first place aimed at the character of a simple bonze worshipping the Eternal Buddha' (Letter 544a). However, the rugged material surface and the sculptural solidity of the head have nothing to do with Japanese art, but with his conception of the simple, workmanly Japanese artist. The reference to a Japanese Buddhist derives from van Gogh's reading of a western view of Japan, Pierre Loti's *Madame Chrysanthème* (1887).

41. *Café Terrace, Place du Forum, Arles, at Night.* September 1888. Oil on canvas, 81 × 65.5 cm. (31⅞ × 25¾ in.) Otterlo, Rijksmuseum Kröller-Müller

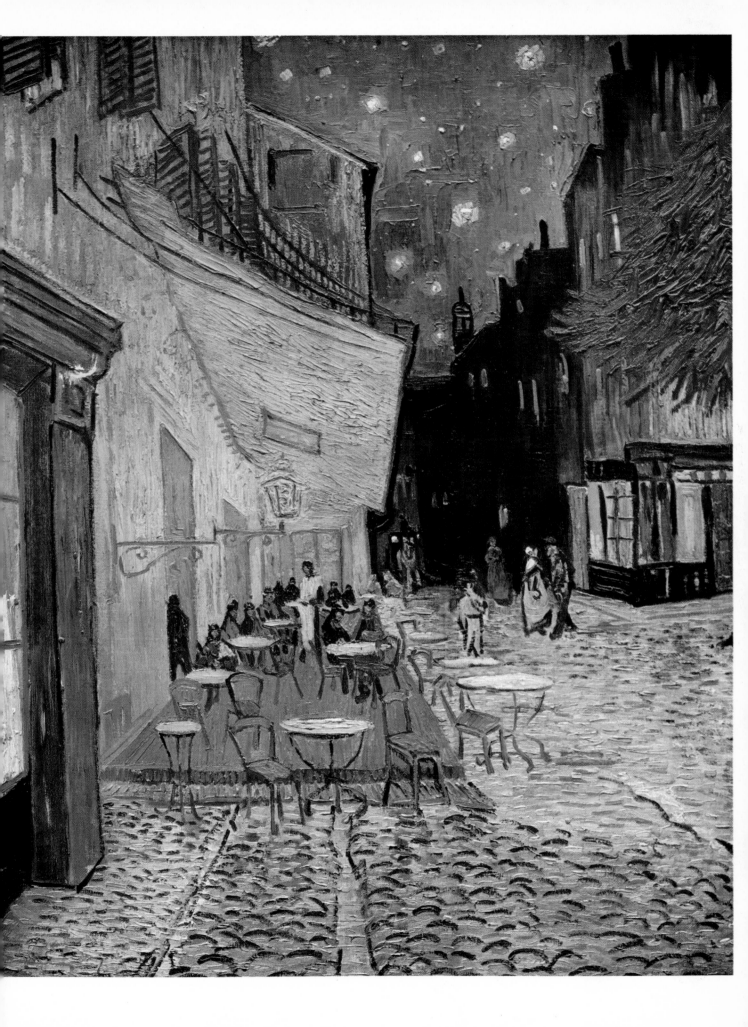

On October 23, Paul Gauguin arrived in Arles, where he stayed a brief two months. Gauguin did not bring any of his paintings with him to Arles and van Gogh had to rely on Emile Bernard's *Breton Women in a Meadow* (1888), which Gauguin had brought, to acquaint himself with the new work his friends had been doing in Pont Aven. Their use of an emphatic dark line to simplify the form and delineate decorative areas of colour led van Gogh to experiment with such devices in his own work. Gauguin encouraged him to work from imagination, and free himself from his attachment to nature, to the real, the motif or the person. As his portraits show he was already taking liberties with colour and forms in order to express himself and his view of the world more forcibly than correct observation of externals alone would allow. His Carlylian notion of the world as one vast symbol—or the universe as a Great Book of hieroglyphs—had already led him beyond descriptive realism, but he remained, as was Carlyle, deeply rooted in reality, however much he felt free in pictorial terms to heighten or exaggerate in order to convey that reality which was embodied in or clothed by external appearances.

The painting of Madame Roulin, *La Berceuse* (fig. 44), begun in December and completed in January 1889, reveals the impact of his discussions with Gauguin. The use of the dark contour line, the decorative background, the unmodulated brilliance of the golden face witness his response to Bernard's and Gauguin's work and their adaptation of the devices of Japanese prints. In May 1889 van Gogh made a sketch (fig. 42) of how he would like to see the painting hung, as the centre of a triptych flanked by two large, yellow canvases of sunflowers. He asked that two copies of *La Berceuse* be sent to Gauguin and Bernard as tokens of friendship. However, in this sketch he has altered the positioning of the figure, corrected the perspective and extended her skirts to create a more stable and matronly image; by placing her between the sunflowers he emphatically replaced her in nature.

And later, in December, he categorically rejected the 'abstracting' tendencies under which he had originally conceived the painting. He wrote to Bernard,

As you know, once or twice, while Gauguin was in Arles, I gave myself free rein with abstractions, for instance in the *Woman Rocking* [*La Berceuse*] . . .; and at the time abstraction seemed to me a charmed path. But it is bewitched ground, old man, and one soon finds oneself up against a wall.

(Letter to Bernard 21)

Van Gogh's intentions in *La Berceuse* had always exceeded a mere innovation of style. His numerous discussions of the work in letters to various friends indicate its importance. These letters also provide keys to the meanings it was meant to carry. Its style, simplified forms and strident colour he compared to popular prints, chromolithographs and Epinal woodcuts. The title, *La Berceuse*, not only means the woman who rocks the cradle, but the song she might sing, the lullaby, 'Whether I really sang a lullaby in colours is something I leave to the critics' (Letter 571a to A. H. Koning). He stressed the analogies not only between his painting and music, but with literature—a Dutch author, Frederick van Eeden's *Little Johannes*, as well as Pierre Loti's novel about the isolated and dangerous life of *Icelandic Fishermen* (1886). Loti described a ship's cabin with its old faience crudely-made statue of the Virgin in place of honour as a source of comfort to those far from home. Van Gogh wrote to Theo in January 1889,

. . . the idea came to me to paint a picture in such a way that sailors, who are at once children and martyrs, seeing it in the cabin of their Icelandic fishing boat would feel the sense of being rocked come over them and remember their own lullabies.

(Letter 574)

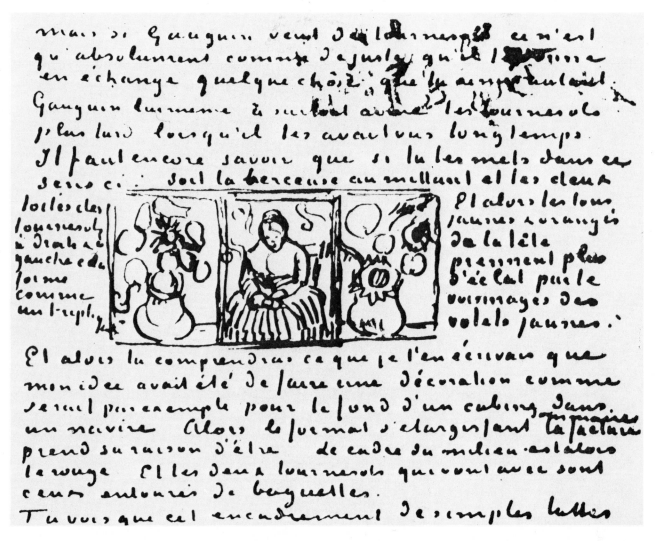

42. Sketch in Letter 592. May 1889. Amsterdam, National Museum Vincent van Gogh

His suggestion that a picture can be a comfort to remind one of the memories of home links back to one of his earliest references to the emotive power a baby's cradle held for him. In a letter of July 1882 many of van Gogh's motifs are mentioned and they provide some insight into this painting done far from his home in Holland at a time of great personal stress,

. . . a small iron cradle with a green cover. I cannot look at this last piece of furniture without emotion, for it is a powerful motion which grips a man when he sits besides the woman he loves with a baby in a cradle near them. And though it was only a hospital where she was lying and where I sat near her, it is always the eternal poetry of the Christmas night with the baby in the stable—as the old Dutch painters saw it, and Millet, and Breton—a light in the darkness, a star in the dark night.

(Letter 213)

55

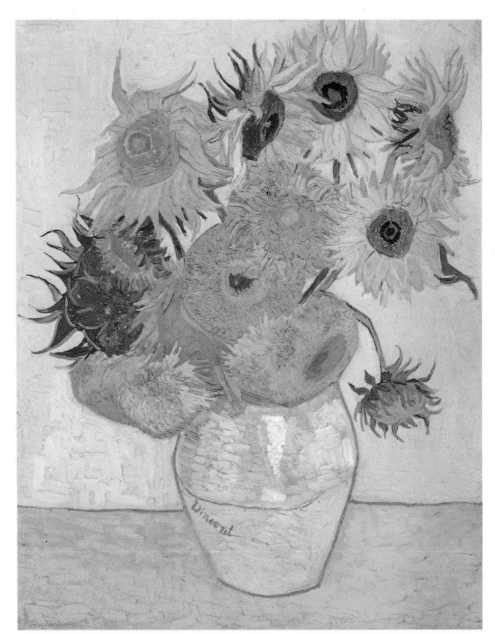

43. *Sunflowers*. August 1888. Oil on canvas, 91 × 71 cm. (35⅞ × 28 in.) Munich, Bayerische Staatsgemalde Sammlungen (photo Blauel)

44. *La Berceuse*. January 1889. Oil on canvas, 93 × 74 cm. (36⅝ × 29⅛ in.) United States, Mr and Mrs Walter Annenberg

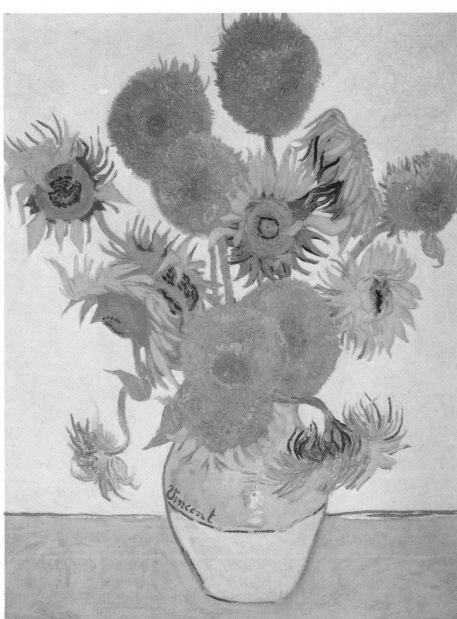

45. *Sunflowers*. August 1888. Oil on canvas, 93 × 73 cm.
(36⅝ × 28¾ in.) London, Tate Gallery

46. *The Factory*. Spring 1888. Pencil, chalk, pen and ink, 25.5 × 35 cm. (10 × 13¾ in.)
London, Courtauld Institute Galleries

Van Gogh's need to situate himself both in a specific place or environment and in the world at large was reflected in the consistency with which he painted or drew views from the window of the houses in which he lived. In Arles, however, his home, The Yellow House, had a particular significance. He hoped it would become the home of the Studio of the South, the centre for a collective of artists led by Gauguin who would effect the renovation of modern art. In anticipation of Gauguin's arrival, he decorated his house with the series of orchards, gardens, sunflowers and portraits painted in the summer of 1888. He also advertised his house by painting its exterior and a view of his bedroom (fig. 48). The significance attached to this work is attested to by the fact that the artist sent sketches of it to both Gauguin and Theo (fig. 47), and a year later made two copies, one of which he sent to his sister, with this explanation, 'I wanted to achieve an effect of simplicity of the sort one finds in *Felix Holt*. After being told this you may quickly understand the picture....' (Letter 15 to Wilhelmina van Gogh). This reference not only suggests that the painting is in some way an oblique self-portrait, but that it is an attempt to represent

58

47. Sketch in Letter 554. October 1888. Amsterdam, National Museum Vincent van Gogh

the kind of modern man that George Eliot portrayed in her novel.

The Artist's Bedroom is a powerful image. The rich colours and varied textures characterize and charge with emotion the everyday objects he uses, the place he lives, sleeps and dreams in, the space he inhabits. How does van Gogh achieve this effect, an effect of his presence in the room, his knowledge and experience of the objects, and the relation of a man to his environment?

It is largely achieved by abandoning a traditional, linear perspective, which defines the situation of objects, their size and character within the frame while placing the spectator at a distance, outside the picture. The differ-

ences between the sketch and the final painting show that van Gogh wanted to give more than merely visual information. In the painting he establishes the relations between groups of objects, conveying memories of touch—the texture and weight of the furniture and bedding—the sensations arising from their use, and the relations between the objects as he moved about the room. This accumulation of detail and experiences is built into a space which we can never fully grasp if we remain outside the picture. The painting invites our active participation in the reconstruction of those relationships and the recreation of that lived-in space.

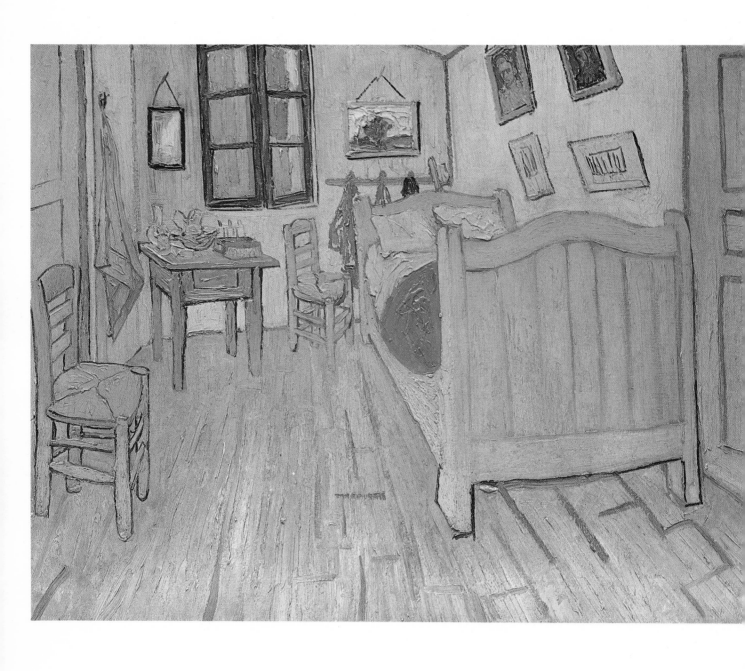

48. *The Artist's Bedroom in Arles.* October 1888. Oil on canvas, 72 × 90 cm. (28⅜ × 35⅜ in.)
Amsterdam, National Museum Vincent van Gogh

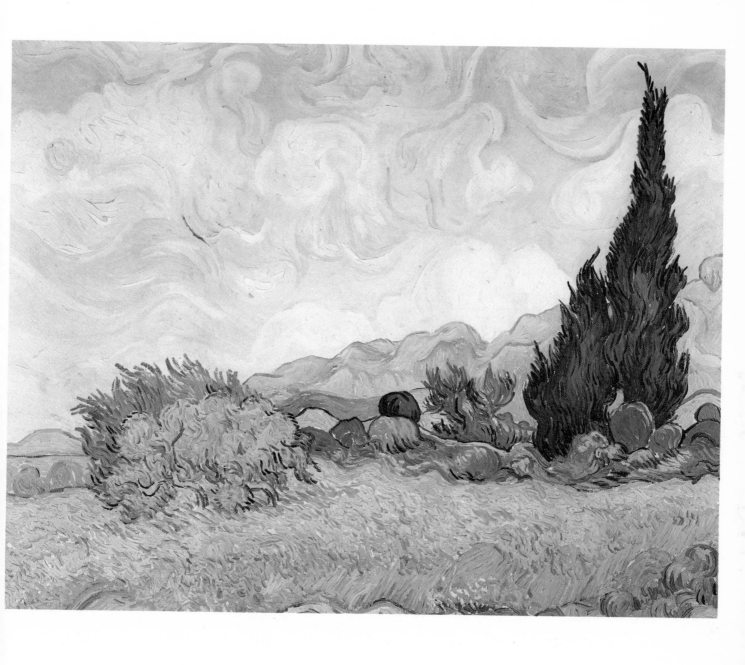

49. *Wheatfield with Cypresses.* July 1889. Oil on canvas, 72.4 × 91.4 cm. (28½ × 36 in.)
London, National Gallery

50. *Landscape near Montmajour*. July 1888. Pen, ink and chalk, 49 × 61 cm. (19¼ × 24 in.)
London, British Museum

In July 1888, van Gogh wrote to his brother saying that although two of his most recent drawings, one of the Crau (F1420) and the other of the landscape near Montmajour (fig. 50) did not look Japanese, they were more so than others. He was not referring to his characteristic drawing technique as being influenced by Japanese prints. While it is true that the various graphic systems which he used in Arles can all be found in the prints, his penmanship is not calligraphic, and the style is definitely non-oriental. In fact, the complex pattern of lines and dots can be found in drawings and prints of western artists whose work he admired, Rembrandt, Delacroix and Millet. In ascertaining what made the landscape Japanese we should bear in mind that van Gogh often compared a painting, or a landscape or a scene which he observed with a passage from literature—from a book or article he had read. It seems that in this case he was identifying the motif in the drawing with the Japanese landscape as it had been described by the popular

62

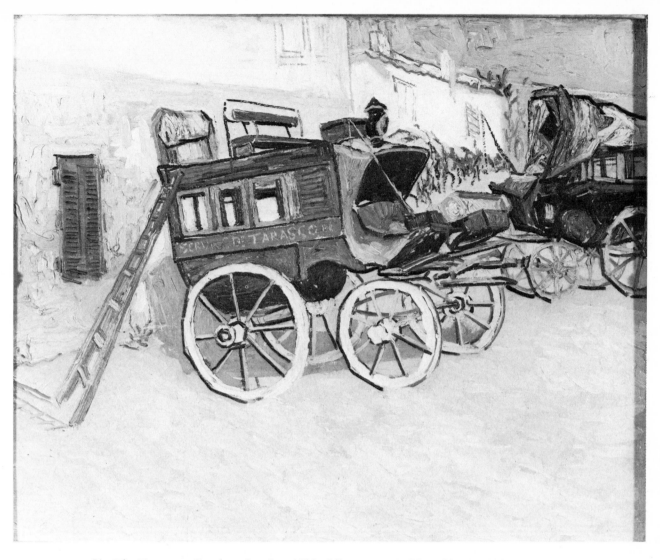

51. *The Tarascon Coaches.* October 1888. Oil on canvas, 72 × 92 cm. (28⅜ × 36¼ in.)
New York, Mr and Mrs Henry Pearlman

nineteenth-century author Pierre Loti in his novel *Madame Chrysanthème*. Van Gogh had read this novel in June and had immediately fallen under the spell of its narrative, basing his view of Japan as a simple, primitive civilization largely on this source.

The landscape in this drawing is animated, not only by the graphic systems employed, but by the presence of man moving through the landscape, a man at work ploughing, two figures walking, an old horse-drawn carriage, and the symbol of modern society with its interconnecting system of transport, the railway train. The old and the new are juxtaposed, and we can recall the descriptions of Drenthe,

'where progress had got no further than the stage-coach or barge', in order to realize the full significance of this juxtaposition.

In a painting of October 1888 (fig. 51), we find an analogous process at work. Under the influence of a literary description in Alphonse Daudet's provençal novel, *Tartarin de Tarascon* (1872), van Gogh painted some old coaches, old-fashioned diligences. In describing this work to Theo he cryptically reminded his brother of a certain passage in the novel—the bitter complaint of an old Tarascon coach against its replacement by the new railway train.

63

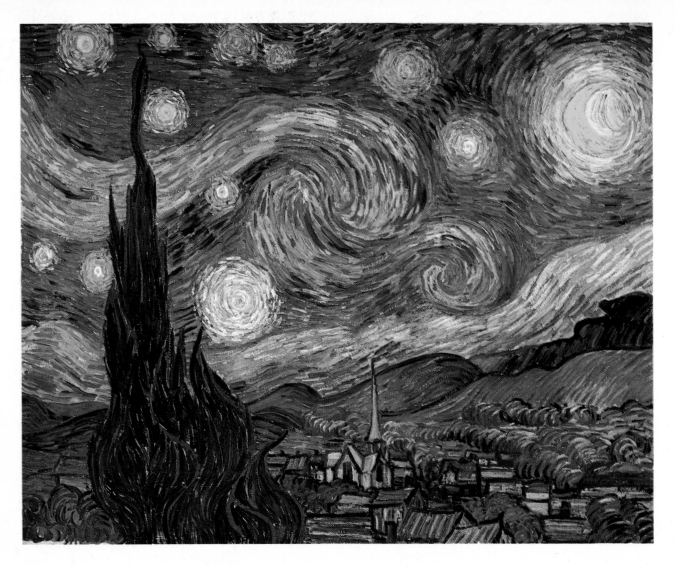

52. *Starry Night*. June 1889. Oil on canvas, 73 × 92 cm. (28¾ × 36¼ in.) New York, Museum of Modern Art

I should like to paint the portrait of an artist friend, a man who dreams great dreams, who works as the nightingale sings, because it is his nature. He'll be a blond man. I want to put my appreciation, the love I have for him into the picture. So I paint him as faithfully as I can, to begin with.

But the picture is not yet finished. To finish it I am going to be an arbitrary colorist. . . . Behind the head, instead of painting the ordinary wall of the mean room, I paint infinity, a plain background of the richest, intensest blue that I can contrive, and by this simple combination of a bright head against a rich blue background, I get a mysterious effect, like a star in the depths of an azure sky.

(Letter 520, August 1888)

During the troubled but productive year van Gogh spent in the sanatorium of Saint Paul-de-Mausole at Saint Rémy in Provence (May 1889 to May 1890), his revitalized interest in Millet and Rembrandt and his desire to return to the north, both geographically and aesthetically displaced his identification of Provence with Japan. Early intimations of returning memories of the north are announced in a painting done from imagination under Gauguin's influence in November 1888, *Memory of the Garden at Etten* (Leningrad, Hermitage); they developed into a richly resonant pictorial conception in *Starry Night* (fig. 52).

53. *Portrait of Eugène Boch*. September 1888. Oil on canvas, 60 × 45 cm. (23⅝ × 17¾ in.) Paris, Louvre (Jeu de Paume)

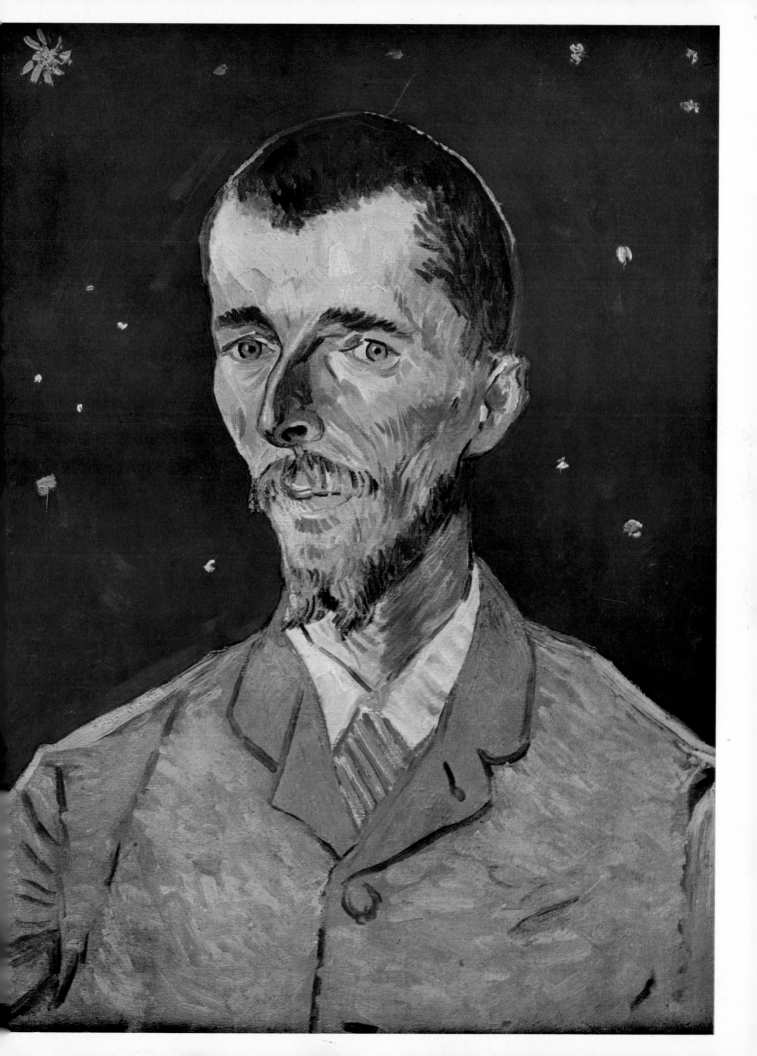

Apart from mentioning that he had painted a starry night, van Gogh gave no explanation of the meaning of the picture other than that it was neither romantic nor religious but based on Delacroix's colour and spontaneous drawing, in order to express the 'purer nature of the countryside compared with the suburbs and cabarets of Paris' (Letter 595). However, it was more than this. In fact, it was one of his most important statements and he was extremely upset that no one understood the meanings signified by the scene and its components; they were not only recurrent motifs throughout van Gogh's own œuvre, but common symbols in so much nineteenth-century literature and thought—a Brabant church, peasant cottages, smoking chimneys, lighted windows, the provençal cypress, the crescent moon, the stars and planets. Images like these can be found in Eliot, Dickens, Zola, Daudet, Longfellow, Whitman, and Carlyle. Many possible layers of meaning are built up in *Starry Night* around memories of places and events, poems and novels van Gogh had read, prints and paintings he had seen. Here we can suggest a few of the notions, neglected by previous studies, that provide a point of departure.

I watched her sleeping . . . protected by this bright night which had always given me beautiful thoughts. Around us the stars continued their silent progress gentle like a great flock of sheep: and for a moment I imagined that one of these stars, the most lovely and beautiful lost its way and came to rest on my shoulder to sleep. . . .

ALPHONSE DAUDET, *Letters from my Windmill*, 'The Stars'

'But look up yonder, Rachel! Look above.' Following his eyes, she saw that he was gazing at a star. 'It ha' shined on me in my pain and trouble down below. It ha' shined into my mind.' . . . They carried him very gently along the fields. . . . It was soon a funeral procession. The star had shown him where to find the God of the poor; and through humility, and sorrow, and forgiveness he had gone to his Redeemer's rest.

CHARLES DICKENS, *Hard Times*, PART III, CH. 6, 'The Starlight' (Read by van Gogh 1879)

In a symbol there is concealment and yet revelation: here therefore by Silence and by Speech acting together comes a double singificance. . . . Thus in many a painted Device or Seal-emblem, the commonest Truth stands out to us proclaimed with quite new emphasis.
. . . .
Then sawest thou that this fair Universe, were it in the meanest province thereof, is in very deed the star-domed city of God.

THOMAS CARLYLE, *Sartor Resartus*

Over the roof one single star, but a beautiful large, friendly one. And I thought of you all and of my own past years and of our home.

(Letter 67, 1876)

And earnest thoughts within me rise,
When I behold afar
Suspended in the evening skies,
The shield of that red star.

. . . .
O fear not in a world like this,
And thou shalt know ere long,
Know how sublime a thing it is
To suffer and be strong

Longfellow, *The Light of the Stars*
(Letter 86, 1877)

. . . but looking at stars always makes me dream, as simply as I dream over the black dots representing towns and villages on a map. Why, I ask myself, shouldn't the shiny dots of the sky be as accessible as the black dots on the map of France? Just as we take a train to reach Tarascon or Rouen, we take death to reach a star.

(Letter 506, 1888)

66

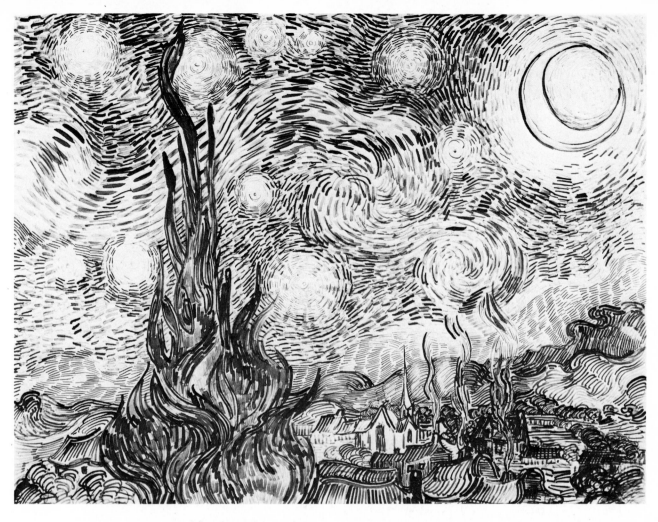

54. *Starry Night*. June 1889. Pen and ink, 47 × 62.5 cm. (18½ × 24⅝ in.) Bremen, Kunsthalle

55. *Peasants at a Meal*. April 1890. Black chalk on paper, 34 × 50 cm. (13⅜ × 19¾ in.)
Amsterdam, National Museum Vincent van Gogh

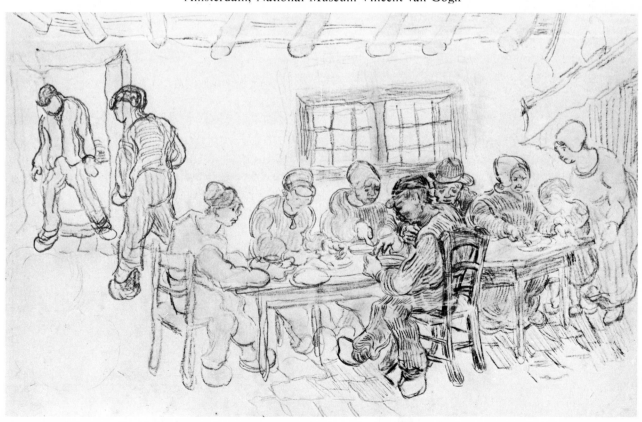

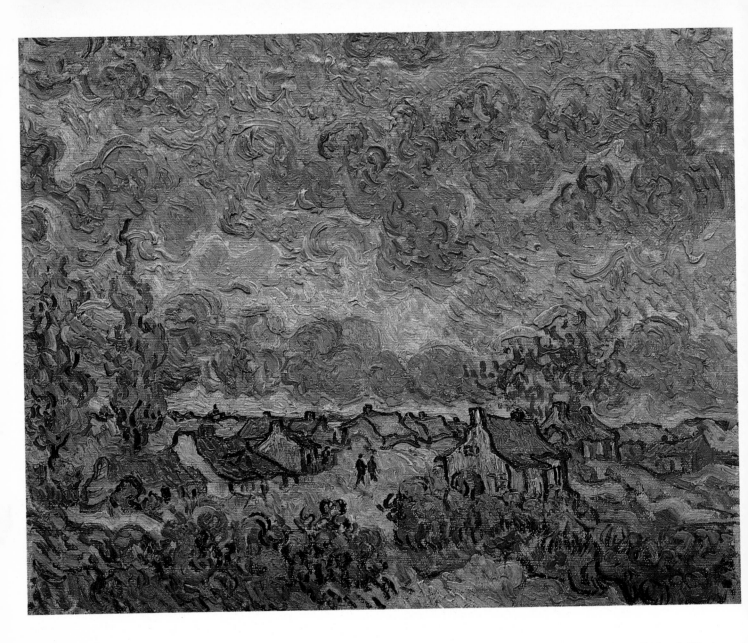

56. *Winter Landscape: Memories of the North.* March-April 1890. Oil on canvas on panel, 29 × 36.5 cm. (11⅜ × 14⅜ in.) Amsterdam, National Museum Vincent van Gogh

In Saint Rémy van Gogh experimented with a more subdued and subtle northern coloration at the same time as he reworked in rich oil, copies of works by northern artists he had always loved and admired, notably Millet and Rembrandt (fig. 60). Moreover he copied his own, earlier work. The drawing (fig. 55), reminiscent of the *Potato Eaters*, belongs to a series of drawings of peasants like those done in Nuenen in 1885, and a painting (fig. 56) is in fact directly taken from the page of sketches

he had sent to Theo from Drenthe in autumn 1883 (fig. 16). Once again when personal crisis intensified the need for a secure place in a known, familiar world, these works give expression to the deeply rooted notion of a homeland in pictures.

Van Gogh had entered hospital in Saint Rémy in May 1889 as a voluntary patient, in

57. *Self-portrait.* September 1889. Oil on canvas, 65 × 54 cm. (25⅝ × 21¼ in.) Paris, Louvre (Jeu de Paume)

68

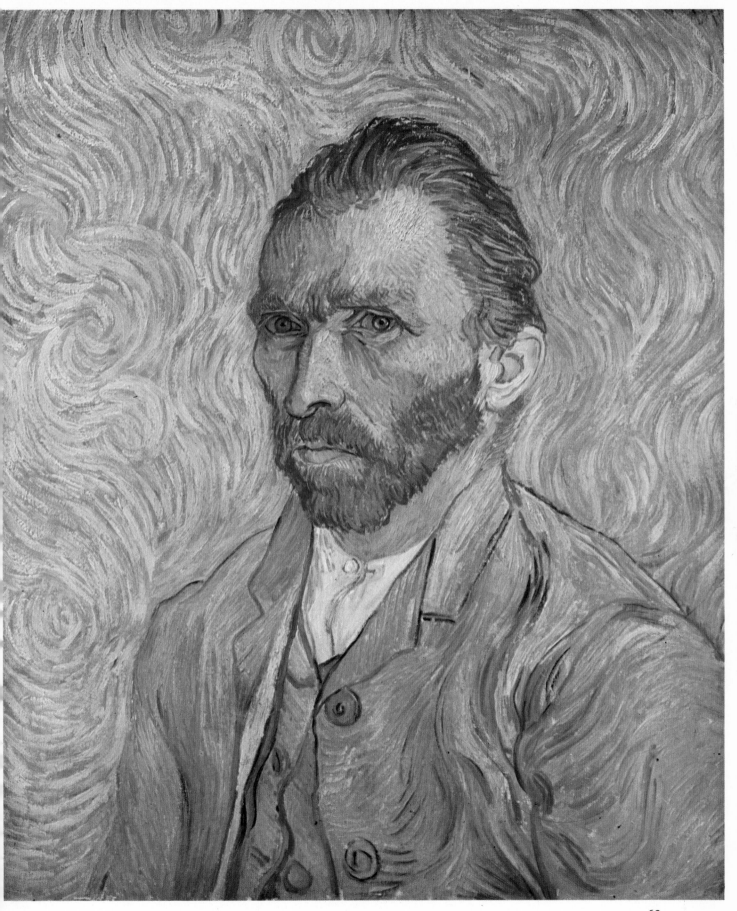

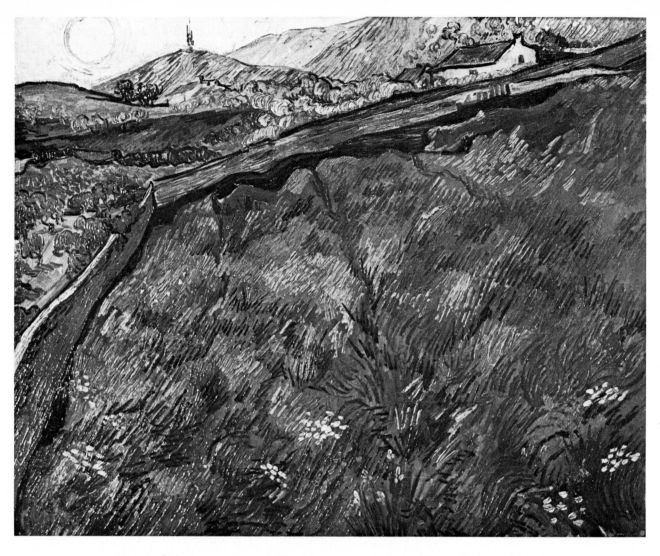

58. *Field Enclosure*. Spring 1890. Oil on canvas. 72 × 92 cm. (28⅜ × 36¼ in.)
Otterlo, Rijksmuseum Kröller-Müller

order to be able to work undisturbed and receive the appropriate care during the sporadic attacks of his psychomotor epilepsy. This condition is not uncommon and it is thought that it results from slight injuries to the temporal lobes of the brain incurred during birth. It is characterized by short attacks during which the patient suffers intensification and distortion of perceptions and emotional states. This is followed by a period of lethargy, lasting a few days or weeks, and finally complete recovery for prolonged periods. It would seem that van Gogh was aware of the nature of the condition; he even anticipated the precise times of attacks, during

some of which he managed to finish the picture he was working on (fig. 62). Understandably, he took great interest in this disease, and in September 1889, he reported to Theo that he had read an article in *Le Figaro* about the nervous illness of the Russian author, Dostoevsky, who, we now know, also suffered from psychomotor epilepsy. Indeed, his novel *The Idiot* (1868) contains superb and lengthy accounts of what happened during an attack—brilliance of colour, intensification of visual sensations as this following passage shows,

That there was, indeed, beauty and harmony in those abnormal moments, that they really contained

70

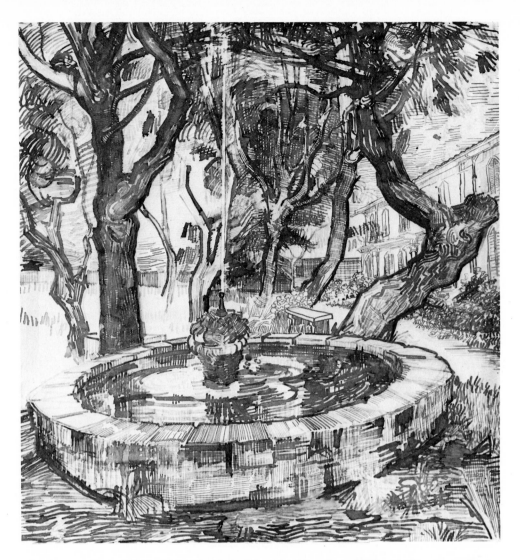

59. *The Fountain in the Garden of Saint Paul-de-Mausole.* May-June 1889. Chalk, pen and ink on paper, 49.5 × 46 cm. (19½ × 18⅛ in.) Amsterdam, National Museum Vincent van Gogh

the highest synthesis of life, he could not doubt, nor even admit the possibility of doubt. He felt that they were not analogous to the fantastic and unreal dreams due to intoxication by hashish, opium or wine. Of that he could judge, when the attack was over. These instants were characterized—to define it in a word—by an intense quickening of the sense of personality.

DOSTOEVSKY, *The Idiot*, PART II, CH.V

At the time of writing about the article, van Gogh felt himself fully in control. He wrote 'my brain is working in an orderly fashion and I feel perfectly normal' ((Letter 604). Concurrently he was painting several portraits —of the head attendant, the attendant's wife and two of himself. The *Self-portrait* (fig. 57) employs the gentler colours that characterize much of the Saint Rémy work and the textured brushwork and suggestive patterned background that he frequently used to add particular meanings to a portrait (see figs. 29, 35, 40). Here the solid, calm figure gazes out from a background of swirling rhythms that consciously incorporate the heightened sense of movement that may have been more apparent during the moments preceding an attack. Thus in a period of complete lucidity, he, like the writer Dostoevsky, recollects in quietude some of those intensified experiences of self to which his condition temporarily gave rise.

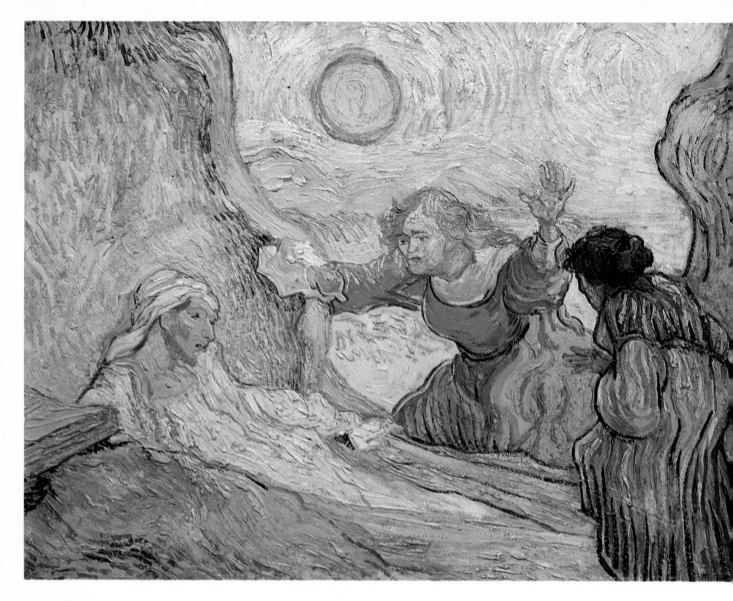

60. *The Raising of Lazarus* (after Rembrandt). May 1890. Oil on canvas, 48.5 × 63 cm. (19⅛ × 24¾ in.)
Amsterdam, National Museum Vincent van Gogh

During his year at Saint Rémy van Gogh made many oil copies of reproductions of works by other artists. Copies done thus in his maturity served to establish both his debts and his achievements. Perhaps the most important copy he painted is his transcription of Rembrandt's famous etching, *The Raising of Lazarus* (fig. 60). In it, line and colour work together to signify the renewal of life and its source. Significantly, van Gogh omitted the figure of Christ, from whom, in the print, that new life emanates, signified by the light that radiates from his person to dispel the darkness of death. The sun replaces the figure of Christ

in van Gogh's painting. His notion of modern art was founded in the primary significance of colour. In reworking a black and white etching by the master of chiaroscuro van Gogh asserts the modernism of colour by the eminence he gives to the natural source of light and colour, the sun, whose light is literally and materially dispersed throughout the painting by the fact that its colour, its pigment, is mixed with every other colour on the canvas. Thus he states his modernism, which both acknowledges his roots and establishes the nature of the modern transformation. He simultaneously pays homage to Rembrandt and lays claim to

72

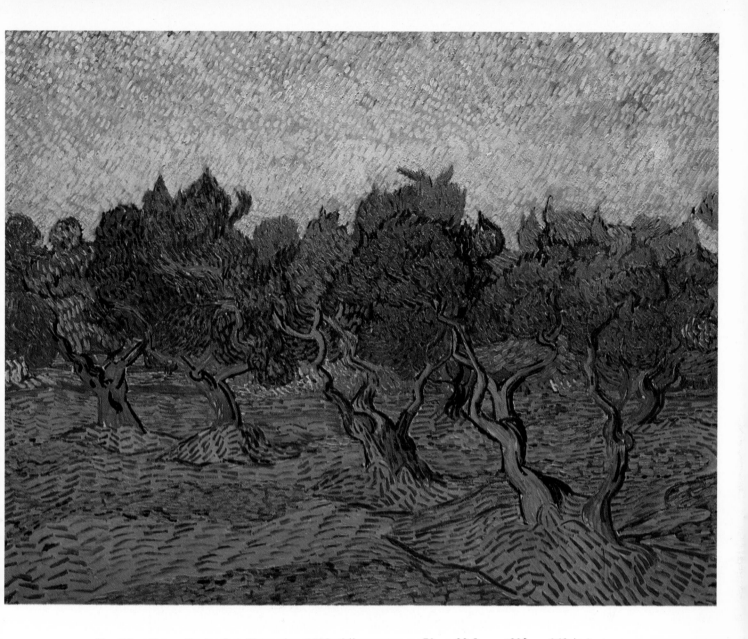

61. *Olive Trees*. September-December 1889. Oil on canvas, 73 × 92.5 cm. (28¾ × 36⅜ in.)
Amsterdam, National Museum Vincent van Gogh

his succession to this older Dutch master—a notion that intriguingly fulfils a statement made by the de Goncourt brothers in their Journal,

The future of modern art, will it not lie in the combination of Gavarni [an illustrator] and Rembrandt, the reality of man and his costume transfigured by the magic of shadows and light, by the sun, a poetry of colours that will fall from the hand of a painter?

(12 November 1862)

But the transformation in his copies is still partial, in one sense. The iconographic reference is still recognizably Biblical. In one of the major motifs in the Saint Rémy work, the olive groves, he attempted a more radical transformation, which avoided traditional iconography and was based entirely on nature. The series of olive groves, with their saddened and sombre colours and struggling forms are addressed both to the real—the olive, the typical tree of the south, and to the symbolic—

73

62. *The Quarry*. October 1889. Oil on canvas, 60 × 72.5 cm. (23⅝ × 28½ in.) Amsterdam, National Museum Vincent van Gogh

the historical groves near Jerusalem, in the Garden of Gethsemane. Once again the figure of the historical Christ is absent, but the meanings are not obscure. Van Gogh explained his way of working to Bernard,

. . . one can try to give an impression of anguish with aiming straight at the historic Garden of Gethsemane; . . . it is not necessary to portray the characters of the Sermon on the Mount in order to produce a consoling and gentle motif.
Oh! Undoubtedly it is wise and proper to be moved by the Bible, but modern reality has got such a hold on us that, even when we attempt to reconstruct the ancient days in our thoughts abstractly, the minor events of our lives tear us away from our meditations and our own adventures thrust us back into our personal sensations—joy, boredom, suffering, anger or a smile.

(Letter to Bernard 21, December 1889)

In May 1890 van Gogh moved north, passing through Paris for a few days to visit Theo and meet his wife and small son, Vincent (born

January 1890), before going to the village of Auvers-sur-Oise. Auvers, lying in a beautiful plain twenty miles north-east of Paris, had long associations with painters: Cézanne and Pissarro had worked there and it was through the latter's agency that van Gogh's move had been arranged.

His letters from Auvers to his family in Holland re-established his personal and artistic roots in the north. To his mother he wrote,

For the present I am feeling much calmer than last year and really the restlessness in my head has greatly quieted down. In fact, I always believed that seeing the surroundings of the old days would have this effect.

(Letter 650)

But Auvers was not the surroundings of the old days; he had never been there before. However, a letter to his sister Wil reveals how he was characteristically identifying the plains, cottages and villages of Auvers with the country and people of Drenthe and Brabant. Indeed the parallels extend to comparable states of mind; his letters and pictures re-iterate his preoccupations with feelings of loneliness and nature's comfort, isolation and the need for a community of people, integrated with nature. In Auvers we witness a coming together of themes and motifs that had dominated him since the beginning of his artistic career. The remarkably large *œuvre* produced in sixty-six working days at Auvers contains studies of cottages, views of panoramic, Michel-like plains as reminiscent of the Crau at Arles as of the peatfields of Drenthe, studies of peasants and portraits. Some works of landscape are touchingly empty but none the less draw the spectator into their wide embrace; others are busy with peasants at work; and one or two juxtapose the peasant to a building, home or, at times, the church. In his letters he compares this

74

63. *Old Vineyard with Peasant Woman*. May 1890. Pencil and wash on paper, 43.5 × 54 cm. (17⅛ × 21¼ in.) Amsterdam, National Museum Vincent van Gogh

motif to studies done in Nuenen, but they also recall some of his earliest works, from the Borinage (figs. 1 and 2). But this continuity of themes is carried into a fuller resolution of a pictorial vocabulary appropriate to the realization of those themes in both line and colour, which are brought closer together than ever before.

The drawing, *Old Vineyard with Peasant Woman* (fig. 63), is a reworking of a long-standing motif, the peasants, their dwellings, the land they work in and on. But the marks on the paper and the rhythm of lines do not delineate independent objects, separated in space. They draw all forms of life and objects into an indivisible unity; they construct an interrelated totality through flowing lines that convey movement and substance, growth and, most importantly, claim the figure as part of and continuous with this totality.

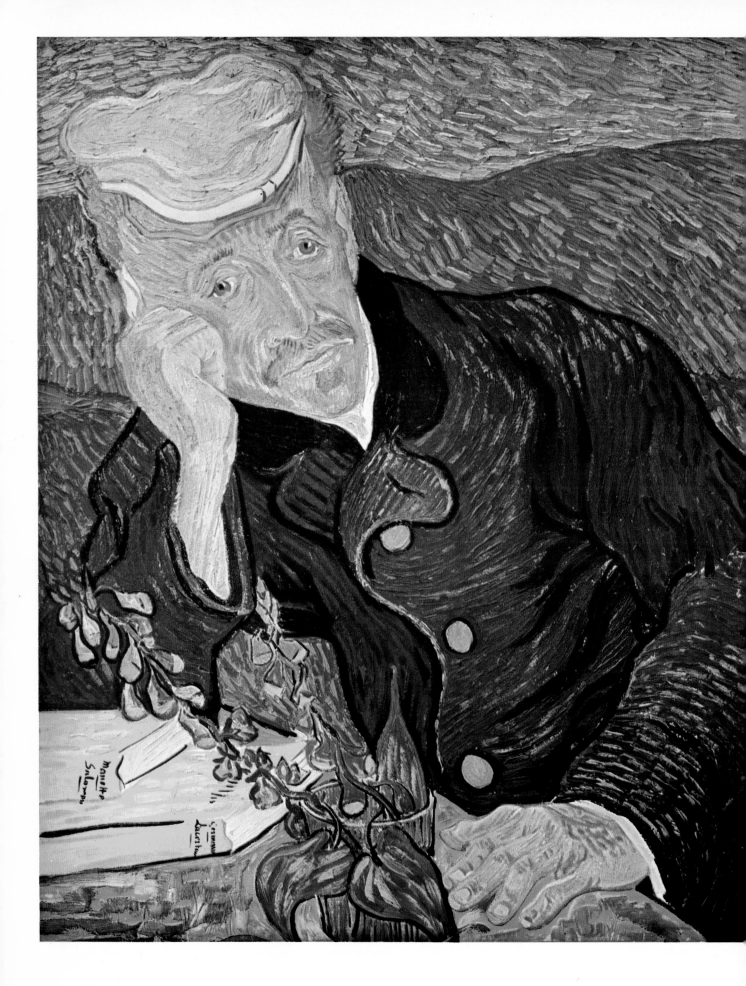

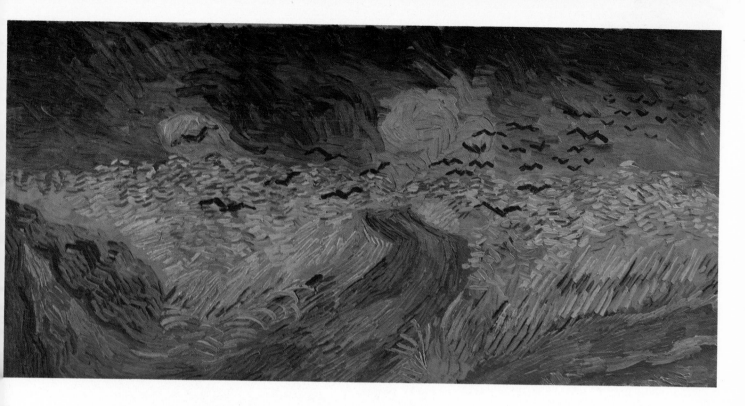

65. *Crows in the Wheatfields.* Early July 1890. Oil on canvas, 50.5 × 100.5 cm. (19$\frac{7}{8}$ × 39$\frac{5}{8}$ in.)
Amsterdam, National Museum Vincent van Gogh

What impassions me most—much, much more than all the rest of my métier—*is the portrait, the modern portrait. I seek it in colour and surely I am not the only one to seek it in this direction. . . . I should like to paint portraits that would appear after a century to the people then living as apparitions.*

(Letter to Wilhelmina 22)

I have painted a portrait of Dr Gachet with the heart-broken expression of our time.

(Letter 643)

I painted a portrait of Dr Gachet with an expression of melancholy, which would seem like a grimace to many who saw the canvas. And yet it is necessary to paint like this, for otherwise one could not get an idea of the extent to which, in comparison with the calmness of the old portraits, there is expression in our modern heads, and passion, like a waiting for something, a development. Sad, yet gentle, but clear and intelligent. This is how we ought to make many portraits.

(Letter to Wilhelmina 23, June 1890)

64. *Portrait of Doctor Gachet.* June 1890. Oil on canvas, 66 × 57 cm. (26 × 22$\frac{1}{2}$ in.) New York, Private Collection

They are vast fields of wheat under troubled skies and I did not need to go out of my way to express sadness and extreme loneliness. I hope you will see them soon—for I hope to bring them to you in Paris as soon as possible, since I almost think that these canvases will tell you what I cannot say in words, the health and the restorative forces that I see in the country.

(Letter 649)

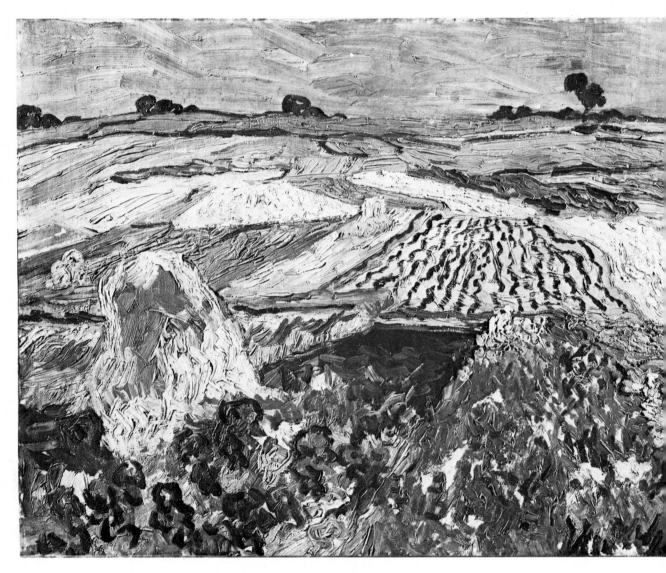

66. *Plain at Auvers.* June 1890. Oil on canvas, 50 × 101 cm. (19¾ × 39¾ in.)
Vienna, Kunsthistorisches Museum

Yesterday and the day before I painted Mlle Gachet's portrait. . . . I have noticed that this canvas goes very well with another, horizontal one of wheat, as one canvas is vertical in pink tones, the other pale green and yellowish-green, the complementary of pink; but we are still far from the time when people will understand the curious relations between one fragment of nature and another, which all the same explain and enhance each other. But some certainly feel it, and that's something.

(Letter 645)

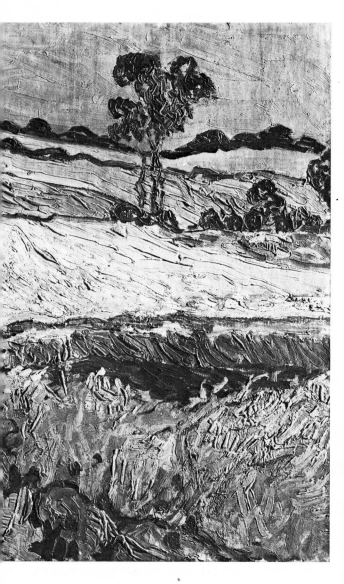

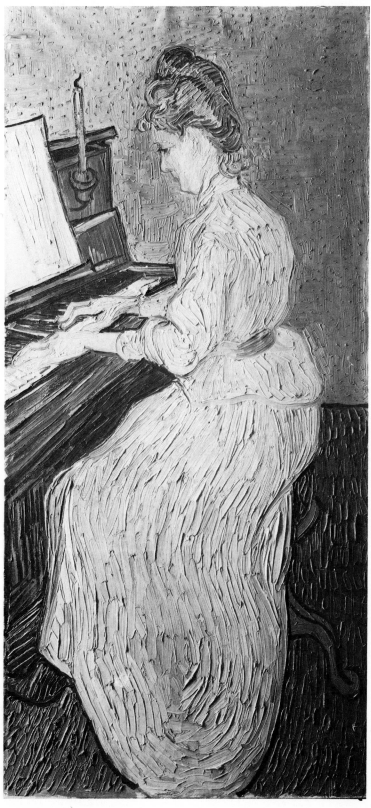

67. *Marguerite Gachet at the Piano*. June 1890. Oil on
canvas, 102 × 50 cm. (40⅛ × 19¾ in.) Basle,
Kunstmuseum

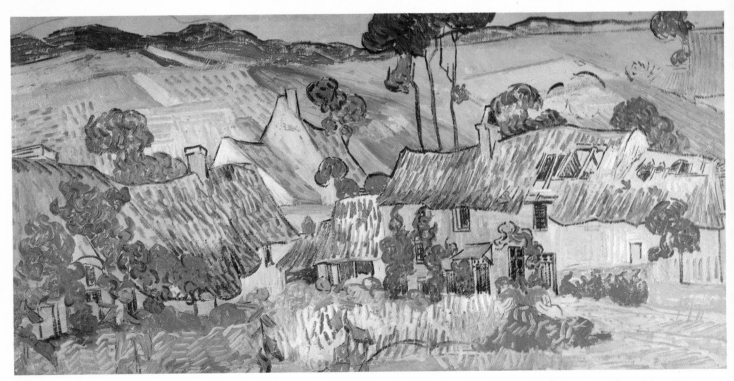

68. *Farms near Auvers*. Late July 1890. Oil on canvas, 50 × 100 cm. (19¾ × 39½ in.) London, Tate Gallery

As for myself, however, the most admirable thing I know in the domain of architecture is the rural cottage with a moss-covered thatched roof and a blackened chimney. (Letter to Bernard 20, October 1889)

The concerns expressed in these letters and the evolution of his pictorial language in the Auvers period not only reaffirm the continuity of van Gogh's endeavours as an artist but establish his particular place in late nineteenth-century and early twentieth-century art. He can be compared with the other great Post-Impressionist, Paul Cézanne (1839-1906), in whose work we see a similar attempt to respond to the change in sensibility, to realize a pictorial equivalent for a world in constant flux, a totality which demanded transformation of the role of colour, the movement and meanings of line, and the conventions for the depiction of space.

After his death, van Gogh's work was appropriated by writers and artists whose own aesthetic and political allegiances as symbolists or expressionists have obscured the character of his art. But some French artists, working in the first decade of the twentieth century at 'the moment of Cubism', saw in van Gogh something else, something which they recognized as a vital and meaningful contribution to the revolution in artistic practice which the new century demanded. Amongst these artists, one of the most perceptive was the young André Derain (1880-1954), who realized the affinities in the work of van Gogh and Cézanne. In 1902 he wrote to his colleague, Maurice Vlaminck (1876-1958),

Soon it will be one year since we saw the work of van Gogh and his memory haunts me permanently. More and more I see his true meaning. Cézanne also has great power. . . . Van Gogh offers not so much a total cohesion as a unity of spirit.

And a year later, in 1903, Derain elaborated,

I consider that no difference exists between a tree which is located, lives and dies—and a man—and that equally, the thoughts and despairs of man undergo a parallel development to the tremulous movement of a leaf; their existence is solely conditioned by their environment.